By Hand

By Hand

The Use of Craft in Contemporary Art

Shu Hung and Joseph Magliaro, editors

Princeton Architectural Press, New York

Published by
Princeton Architectural Press
37 East Seventh Street
New York, New York 10003

For a free catalog of books, call 1.800.722.6657.
Visit our web site at www.papress.com.

Design: Shu Hung and Joseph Magliaro
Editing: Clare Jacobson
Editorial assistance: Lauren Nelson and Dorothy Ball

Special thanks to: Nettie Aljian, Nicola Bednarek, Janet Behning, Becca Casbon, Penny (Yuen Pik) Chu, Russell Fernandez, Pete Fitz-patrick, Sara Hart, Jan Haux, John King, Mark Lamster, Nancy Eklund Later, Linda Lee, Katharine Myers, Scott Tennent, Jennifer Thompson, Paul Wagner, Joseph Weston, and Deb Wood of Princeton Architectural Press —Kevin C. Lippert, publisher

Library of Congress Cataloging-in-Publication Data
By hand : the use of craft in contemporary art / Shu Hung and Joseph Magliaro, editors.
 p. cm.
 Includes bibliographical references.
 ISBN-13: 978-1-56898-610-4 (alk. paper)
 ISBN-10: 1-56898-610-6 (alk. paper)
 1. Handicraft in art. 2. Art, Modern—21st century. I. Title: Use of craft in contemporary art. II. Hung, Shu, 1975- III. Magliaro, Joseph.
 N6498.H36B93 2006
 745.5—dc22
 2006002708

Contents

Preface

The idea for *By Hand* came from noticing that a growing number of contemporary artists are producing work with their hands, using methods and materials traditionally associated with craft. These renegades replace the paintbrush with a needle and thread and, instead of standing in front of a canvas all day, spend time hunched over sewing machines and embroidery hoops. Activities historically associated with feminine conventions are stunningly repurposed and, as a result, become disassociated from their quotidian contexts.

Along with the quiet proliferation of handmade work in the art world, there is a similar prevalence in fashion design, industrial design, and the book arts. Handcrafted typography and hand-drawn illustrations are quickly becoming common currency in graphic design, and it is unsurprising to recognize handiwork within other cultural disciplines. Sweaters are hand knit rather than machine produced, industrial designers create highly conceptual one-off items, and books are being printed and bound by hand.

The participants profiled in this book all share a dedication to materials and processes. They admit to spending months on a single piece with no end in sight and, in fact, luxuriate in their long production time. They abandon efficiency to pursue completion in their work, with the results sometimes landing far away from the original design.

What differentiates these artists from their more politically overt fore-bears of the 1970s is their emphasis on personal experiences rather than on a collective social message. The intimate stories and ideas herein reflect the thinking of a single person or a small group of people. These artists depict their experiences using their most immediate and fine-tuned tools—their hands. Art is engaged as a process rather than as a means to an end, and there is a palpable sense of attachment to the materials and methods that are employed. In many cases, the techniques they use have been passed down to them by their mothers and other close relatives, lending them a sentimental importance.

Although the handmade quality of this work alludes to notions of practicality and functionality, it does not exclude an abundance of ideas and original thinking. Many of the artists and designers featured come from a

fine art or liberal arts background and bring the concepts they've studied in print and plaster to the realm of the handmade. Their ideas are thus strengthened by unique materials and contexts.

In making this book we are not attempting to tackle the distinctions between art and design, art and craft, and craft and design. That might require another publication entirely. *By Hand* instead seeks to present a lively and diverse roster of contemporary creative artists who employ methods of hand production in their work. The thirty-two participants are unafraid of letting a bit of themselves show through in their final products. They are happy to leave their fingerprints on their work in an attempt to get closer to their own lives and to the lives of others.

Acknowledgments

By Hand: The Use of Craft in Contemporary Art would not be possible without the participation and cooperation of a number of individuals who contributed their time and resources to the publication.

Our deepest gratitude is extended to the artists who have provided the creative basis for the work featured herein. We also wish to thank the many galleries who assisted in gathering the materials for the book.

Special thanks must go to Clare Jacobson, our editor at Princeton Architectural Press, for championing this project from the beginning. Without her support and expertise, this book would not have been possible. Many thanks also to Deb Wood, the design director at Princeton Architectural Press, for her invaluable design input and feedback.

Many friends sent ideas and forwarded names of artists for consideration. In particular, we wish to thank Carol Lim, Humberto Leon, Ken Miller, and Keith Knittel and Alisa McRonald of dynamo-ville. We appreciate the support of friends like Cynthia Leung and Christian Jankowski.

We would like to thank Rob Wynne and Charles Ruas for their remarkable advice, insight and unwavering support.

We are deeply indebted to Jon Wasserman and Tanya Phattiyakul for producing some of the original photography in the book.

Finally, warm thanks to Jung Jung Hung for her hand-work, which appears on the cover of this book.

Introduction

During the 1990s, artists, designers, and architects were directly inspired by developments in technology. From Jonathan Ive's sleek rendering of the iMac to Bill Viola's multimedia installations to Ryan McGinness's hypersymmetrical vector art, many lauded works accepted and celebrated the digital processes. Personal computers and their associated software became vital tools in the design and implementation of creative ideas, and the work itself was marked by an overall seamlessness and aesthetic perfection.

This trend, in marked contrast to the body-centric, politically charged, late-1980s work of artists like Robert Gober and Annette Messager, produced a sort of global village of digitally networked computer users and helped to promote and maintain a sense of cultural homogeneity. A global cultural style began to take shape and manifested itself in everything from art to films to design. While this new globalism celebrated the possibilities of the computer age, it also threatened a "loss of individuality, of the characteristics that distinguish people, ethnic groups, and even nations."[1]

The "monotonization of the world," as writer Stefan Zweig described it, was accompanied by a lack of exposure to and cultivation of unique and highly personal creative work.[2] Yet, while the fictionalized world of cyberspace flourished and popular media resigned itself to the slickness of MTV, a growing number of artists and designers began to rebel against the ubiquity and singularity of mass production and digital technology.

Unbound Hands

> The last fifteen years have witnessed a period of excess in graphics, with designers producing complex fusions of computer-generated matter that have often confused the presentation of information and achieved limited visual impact.[3]

Although digital production bestowed artists and designers with speed and accuracy, it effaced the often minute and acutely personal details of non-computer-enhanced work. The emergence of handmade and craft-related practices is, in a sense, a response to the omnipresence of technology in everyday life and in artistic procedures. The new fascination with the handmade signifies a

1. Lisa Phillips, *The American Century Art and Culture, 1950–2000* (New York: W. W. Norton & Company, 1999), 336.

2. Stefan Zweig, cited in ibid., 337. Although Zweig was primarily a political writer, this comment relates to his assessment of post–World War II culture.

3. Ann Odling-Shmee, *The New Handmade Graphics: Beyond Digital Design* (East Sussex: RotoVision, 2002), 6. This comment refers to the trend toward more handmade work in graphic design.

rejection of the hyperbolic, synthetic world structured around video conferencing, cell phones, and satellite television. This new group of artists concerns itself with age-old techniques, often passed down from one generation to another, and focuses on detail, craftsmanship, and tactility. Individuals who have grown up surfing the Internet and mastering computer programs are now impassioned by the ideals of the "do-it-yourself" generation. "They employ small gestures or actions that were unanticipated, beyond the reach of the most carefully executed planning."[4]

Such artists are inspired by their contemporaries like Kiki Smith, whose handmade screen-prints, dolls, and illustrations emphasize the physical pro-duction process and celebrate the inherent imperfections of the human hand. Smith believes there is a spiritual power in repetition. Her interest in printmaking stems from the idea that prints mimic what we are as humans. "We are all the same and yet everyone is different."[5] This belief that humanity has a common goal, yet expresses that goal in a multiplicity of ways, helped define the theoretical backbone of the new approach to handmade art. Smith's methods deliberately lay bare the processes of fabrication as gestures of sincerity. They maintain that the physical body is the primary means with which to experience the world and the most obvious tool for the production of creative work.

Smith and other artists are bringing handmade work out of craft shows and into museums. In 2004, the Crafts Council of Great Britain produced a group show entitled "Boys Who Sew," which introduced the work of seven international artists who all used some form of needle and thread to produce work. In the introduction to the exhibition, the curator Janice Jefferies ponders the phrase "to craft."

> As a verb though, "to craft" seemingly means to participate in some small-scale process. This implies several things. First, it affirms the results of involved work. This is not some kind of detached activity.…To craft is to care.…[It] implies working on a personal scale—acting locally in reaction to anonymous, globalized, industrial production.…It may yet involve the skilled hand. Hands feel, they probe, they practice.[6]

4. Andrew Blauvelt, "Strangely Familiar: Design and Everyday Life," in *Strangely Familiar: Design and Everyday Life*, ed. Andrew Blauvelt (Minneapolis: Walker Art Center, 2003), 26.

5. Kiki Smith, cited in Wendy Weitman, "Experiences with Printmaking: Kiki Smith Expands the Tradition," in *Kiki Smith: Prints, Books and Things*, ed. Wendy Weitman (New York: Museum of Modern Art, 2003), 12.

6. Janis Jefferies, notes for Boys Who Sew exhibition, http://craftscouncil.org.uk/boyswhosew/curator.html.

Jefferies goes on to situate this new artistic movement outside of the traditional confines of art, craft, and design.

By Hand

This publication features a group of artists and designers who exemplify Jefferies's philosophy toward the presentation of handmade creative work. The participants reside in cities around the world, proving that the handmade movement is not confined to certain countries. Moreover, they share a tacit disregard for the fact that it was once considered "woman's work." Although some choose to focus thematically on issues of gender, as a whole, they assert that men and women are capable of knitting, crocheting, sewing, and producing handmade work.

These artists profess their love of methodology while revealing their sometimes obsessive work habits. Anna Von Mertens's complex quilts may take up to three months to produce, while Rowena Dring's richly executed canvases require up to five months to complete. The time and labor involved in each piece vary, but in each case the artist exhibits an arresting sense of attachment to the materials and procedures.

The works are simultaneously beautiful and clever, intelligent and purposeful. They evoke and commemorate the long-standing traditions of craft in many ways while putting forth complicated ideas and personal insights. Karen Reimer examines the value and meaning of manual work in her embroideries, spending countless hours copying discarded books and newspapers with a needle and thread. Kent Henricksen subverts the tradition of narrative embroidery with his masked characters and dubious scenarios.

In many instances, the work does not ignore technology but embraces it and employs it strategically with the handmade. Rob Conger perfects and retouches his portraits in Photoshop before mimicking them as latch-hook pieces. Andrew Kuo uses a combination of freehand drawing and Illustrator to execute the foundations for his screen-prints, while Rachel Cattle presents much of her work on-line, through a whimsical Web site reflective of her own personality.

Some of the featured artists choose to work in groups, as small collectives or as anonymous creative organizations. A communal work environment is cultivated through collaboration and continual ideation. The design duo electricwig takes on projects that support their philosophical vision with products that are irreverent, socially aware, and beautifully enacted. Shane Waltener goes so far as to organize knitting circles based in galleries. Slow and Steady Wins the Race chooses anonymity in an effort to cultivate an overriding principle of simplicity, form, and function.

There are artists herein whose messages are not overtly articulated and who employ a more subtle approach to craft. Brendan Monroe's delicate drawings and sculptures reveal intimate engagements between fantastical characters executed with a precise hand and soft colorings. Kelly Breslin's soft sculptures evoke comfort and nostalgia without being overly cloying. The same rings true for Los Angeles–based dynamo-ville's work, which features a range of personality-infused creatures composed of scraps of corduroy and everyday materials.

Many of the pieces in By Hand are seemingly straightforward in their approach but take the viewer somewhere else upon closer inspection. Aaron Spangler's intricate woodcarvings appear to encase worlds within other worlds in their undulating surfaces. The vellum behind Rob Wynne's hand-sewn portraits is transparent enough to expose the loose threads in the background, allowing the viewer to see two depictions at once. Tess Giberson's fashion shows, though temporally succinct, are the result of countless hours of contemplation and refinement.

An awareness of environmental sustainability and a disavowal of mass consumption are themes in the larger context of handmade work, and artists like Project Alabama are firm subscribers to these ideals. This localized collective of fashion designers and seamstresses reuses second-hand materials in their clothing, revisiting fabrics and techniques in innovative ways. The Canadian artist Barb Hunt amasses cast-off army fatigues and repurposes them in her large-scale camouflage installations. Aside from the immutable quality of the material, the final product bears little resemblance to its original constituents.

In the words of the London-based art collective Jan Family, many of these artists "look at simple things that don't get much attention and seek alternatives to routines." By engaging in closer scrutiny of everyday objects and materials, the artists employ handcrafting methods to "alter and take over what they can touch and feel." They infuse their work with strong ideas and inventive narratives—so much so that the personality of the artist is put forth as a key element of the finished product. To craft, meaning "to care," is restored to its original sense, giving this new form of artistic practice its power and its inimitable appeal.

7. Jan Family, *Plans for Other Days* (London: Booth-Clibborn Editions, 2005), back cover.

The projects that follow are accompanied by first-person narratives from each artist. Inviting the participants to present their work in their own words brings each project to life, adding to the intimacy conveyed by the objects.

Satoru Aoyama
Tokyo, Japan, and London, England

I see embroidery as a contemporary method in art that illustrates my artistic thought. To be honest, I've never been influenced by the craft tradition. I don't mind if people want to use my work to discuss the similarities and differences between art and craft, though, because it is open to interpretation.

I studied in the textile department in art school, where I learned this technique during my sophomore year. I first take a photograph of the subject I want to embroider then trace the contour onto organza and embroider it using a sewing machine. I use polyester thread and polyester organza.

These works question the relationship between high and low technology and explore the idea of "speed" in art making and in society. The people I depict are my friends. Intimacy is very important and I like the idea of presenting the everyday. The location I use is mainly Tokyo. The places are both personal and anonymous at the same time.

Yamanote Line, 2003
Polyester thread on polyester organza
7.25 x 7.25 in

Good Morning Tokyo, 2005
Polyester thread on polyester organza
23.25 x 16.75 in

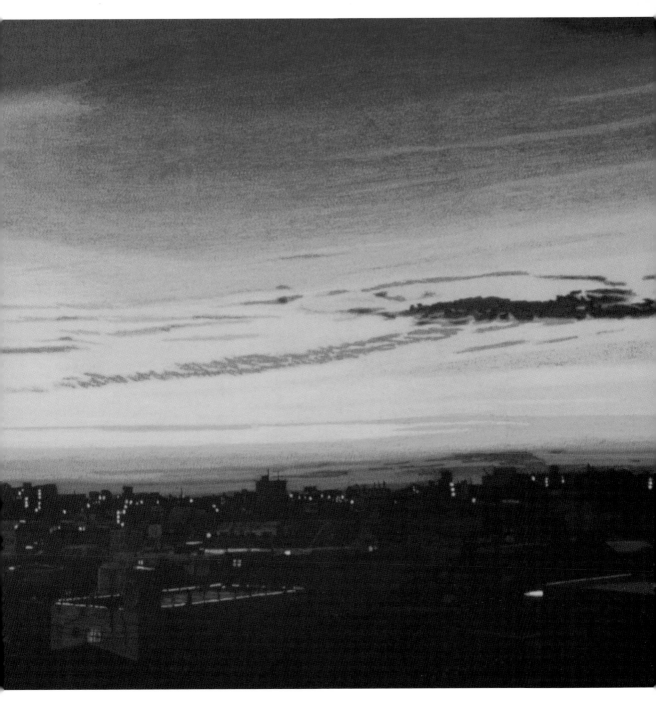

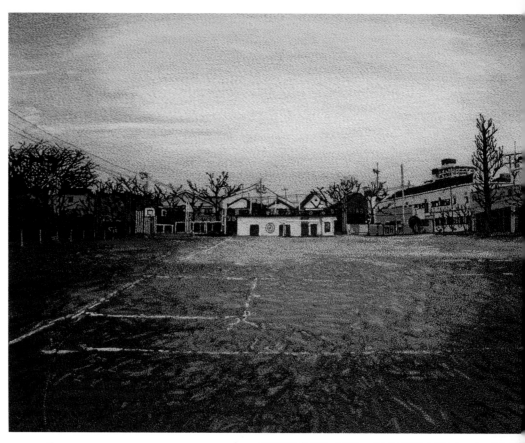

School Yard (East), 2004
Polyester thread on polyester organza
20.75 x 18.75 in

Production of Neil Tennant (Pet Shop Boys),
2004
Polyester thread on polyester organza
7.6 x 7.5 in

Ring (detail), 2005
Polyester thread on polyester organza
13.75 x 9.85 in

BB&PPINC
Robbie Guertin (Monster Rabbit) and Dasha Shishkin (Tough Guy)
Brooklyn, New York

The handmade quality of our books comes from a mix of necessity and of aesthetic choices. In the beginning, we didn't have the money to send off our books to be professionally printed, so we created them in a way that we could do it ourselves. I printed the covers myself and we printed the pages from my computer. Then we just sewed the printed pages in. Aesthetically we both really love well-crafted, handmade books.

I have always loved artists' books, but when I used to go to stores like Printed Matter in New York, it was hard to find an interesting book that really combined artistic elements and also had a well-crafted, handmade feel to it and that was still affordable. What excites me about our books is that they can have a largely handmade feel, but they can be produced in large enough numbers that we can still keep them affordable.

Though we love handmade books, and we have used BB&PPINC as an opportunity to make affordable artists' books, we don't necessarily consider BB&PPINC to be just about handmade artists' books. It is about the characters BB and Pezya and the stories, and we use it as a vehicle to produce whatever sorts of artworks we are into at the time.

At this point, everything is pretty open. We could continue to make more small-edition handmade books, or we could try to make a more mass-produced version of our books. We might try to create more products or even animations about the characters. BB&PPINC is ours, so it gives us the freedom to do whatever we do or don't want to do with it. So that is a really nice thing to have.

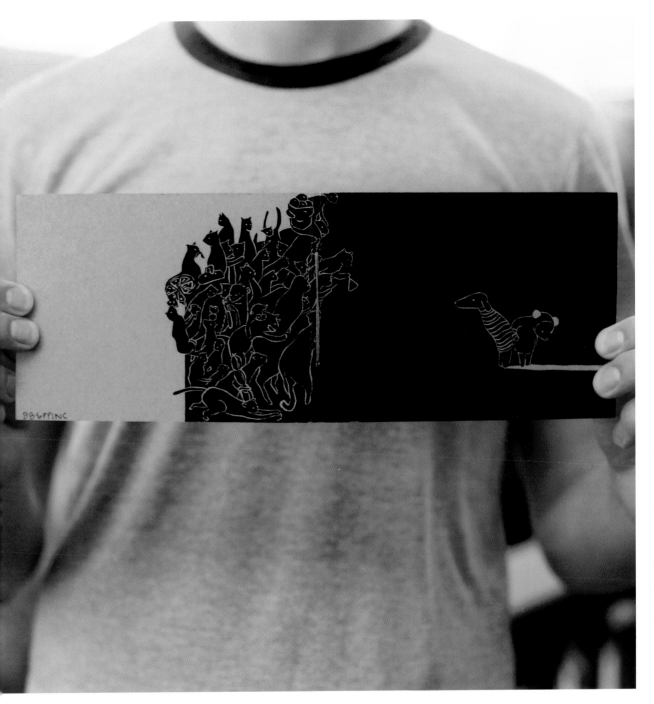

The Party Book, 2004
Hand-printed linocut on cardboard,
hand-stitched binding
6.5 x 4.75 in

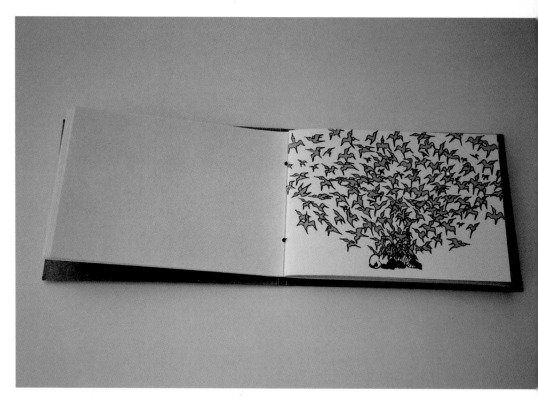

The Birds Book, 2004
Hand-printed linocut on cardboard,
hand-stitched binding
6.5 x 4.875 in

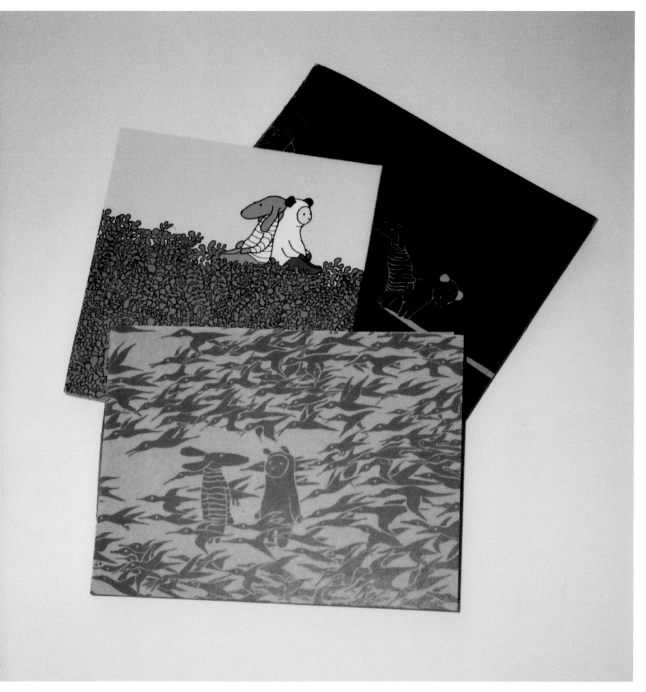

The Party Book, The Birds Book,
and The Plant Book, 2004–2005
Dimensions variable

Kelly Breslin
Chicago, Illinois

Drawing is the basis of my work and sumi ink on paper has always been my mainstay. Ink, brush, and paper give me the most immediate results that I can achieve. The drawings can be done in an intuitive manner, so there is very little in the way of my hand and my idea. Everything else is an extension of this work on paper.

In my work I try to find a material that will translate the idea I have, and often a material or method will find me. For example, I bought a used book on repeat fabric printing ten years ago and taught myself how to silkscreen and became rather obsessed with it. Using fabric to create textile-based sculptures and installations has allowed me to work on a large scale. I like to give my work to friends, and the textile-based pieces have a very comfortable translation between the gallery and a friend's home.

I have established a vocabulary that is invested in love and nature, with a structure based on ikebana and comparative literature. Love is very universal and desire is even more so. Words and imagery that reference these themes can have a very strong impact on people. There is a certain amount of frustration involved in the text pieces—love is bitter or lost and desire keeps slipping from one object to the next just as you get your hands on it.

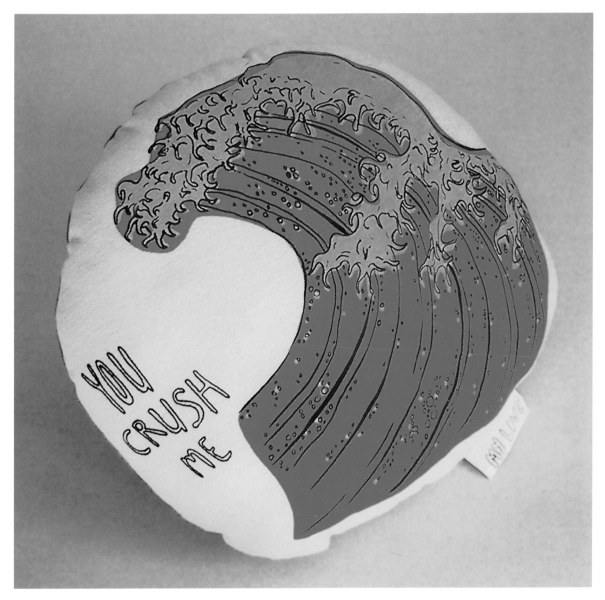

Trawl My Love multiple, 2003
Screen print on sewn fabric
10 x 10 in

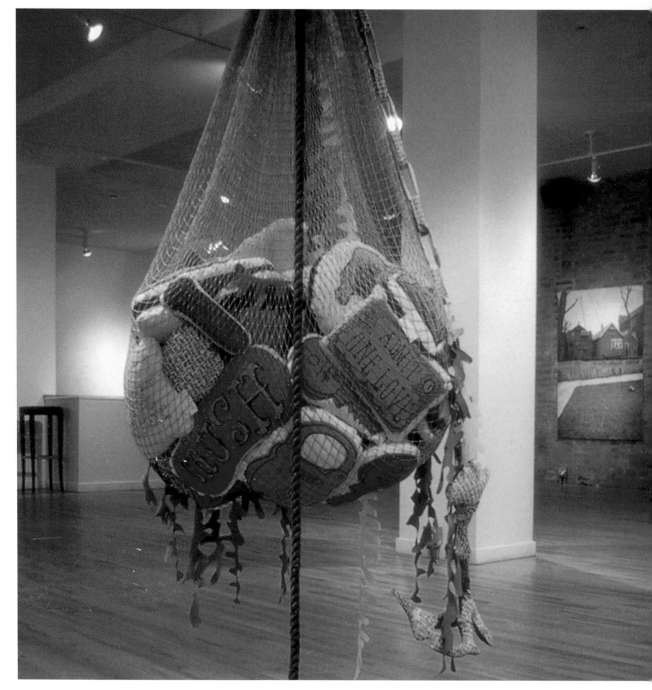

Trawl My Love (installation view), 2003
Mixed media
Dimensions variable

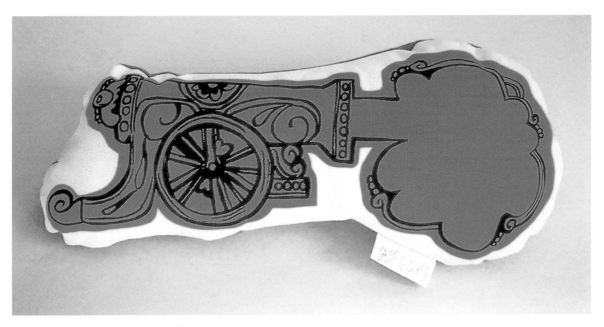

Trawl My Love multiple, 2003
Screen print on sewn fabric
13 x 5 in

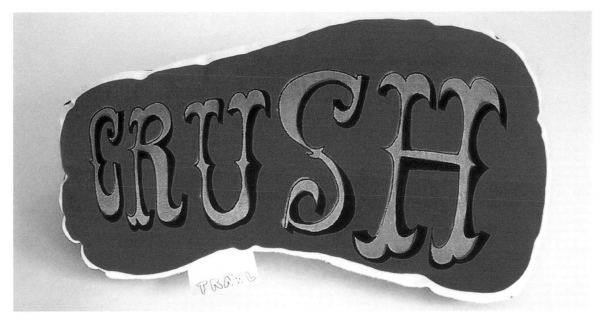

Trawl My Love multiple, 2003
Screen print on sewn fabric
13 x 6 in

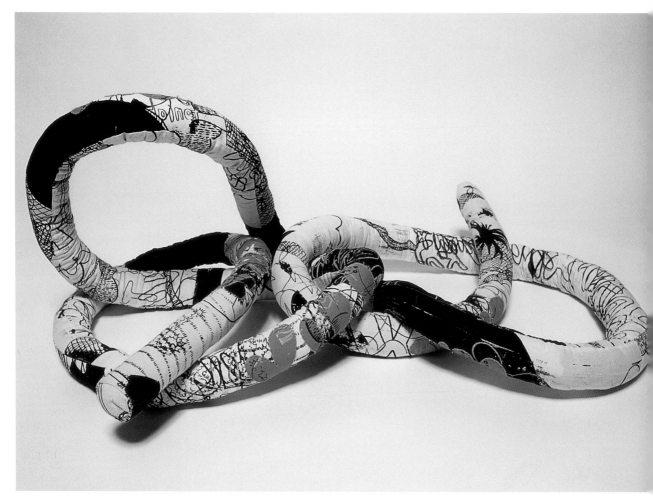

LUX soft rope, 2002
Screen print on fabric with appliqué
60 x 5 x 5 in

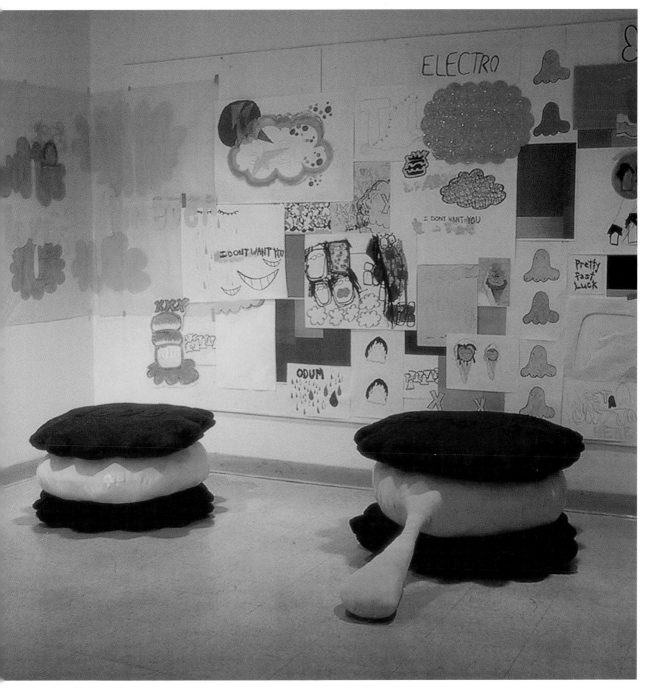

Love Forever (installation view), 2002
Soft sculpture and collage
Dimensions variable

Margarita Cabrera
El Paso, Texas

Since 2001 I have resided along the border between the United States and Mexico. This location has strongly influenced my preoccupation with issues of immigration and the labor and anonymous lives of factory workers.

I create soft sculptures of domestic appliances such as coffee makers, vacuum cleaners, blenders, and hair dryers. These pieces delight viewers with their colorful vinyl fabric, sewn together with thread to re-create the shape of a real appliance. They also invite audiences to learn more about the Mexican people who work in manufacturing companies along the border. I create visual metaphors that reflect the physical and psychological effects of living along the Mexican border. These individuals work for little money in assembly lines in plants such as the one in Puebla, Mexico, where the last Volkswagen Beetle was made in 2003.

I produced an edition of life-sized 1973-model Volkswagen Beetles. This vehicle was a Mexican national symbol as it introduced affordable transportation for all, from delivery cars, to taxis, to police cars, to family cars.

In my soft sculptures I have removed the plastic elements made in Mexico from the bodies of the appliances and replaced them with colorful vinyl. The exposed stitching reflects the hand labor involved in my work and echoes the hand labor of the Mexican workers. In this way, the piece seems unfinished, forgotten, and worn out. The soft body of the sculpture has no inner structure to support itself, thereby exposing its weak exterior form.

Sewing was passed down to me from my grandmother. It was a very lady-like chore to do around the house when I grew up in Mexico City. My family migrated from Mexico City to the United States in the eighties. As a Mexican artist living in the States, I have traveled from one cultural context into another. As a result, disorder and disruption have a particular resonance in my work and are central themes for me.

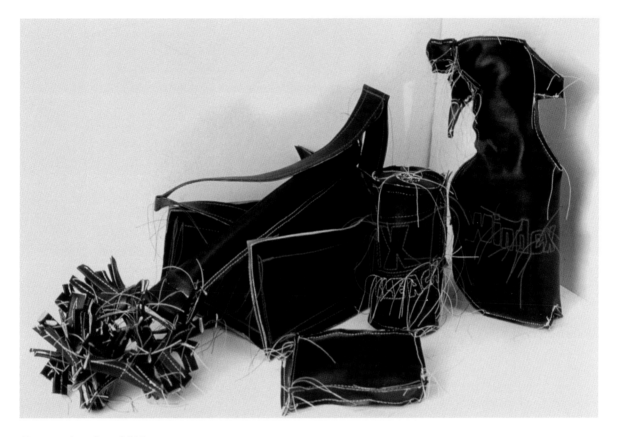

Cleaning Supplies, 2003
Vinyl and thread
Dimensions variable

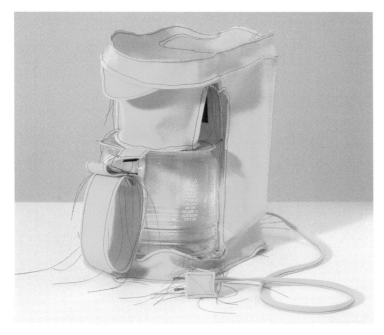

Coffee Maker M.I.M., 2001
Vinyl, thread, Velcro, appliance parts
23 x 23 x 24 in

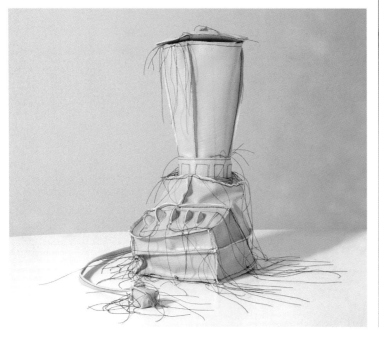

Pink Blender, 2002
Vinyl, thread, appliance parts
14 x 7 x 19 in

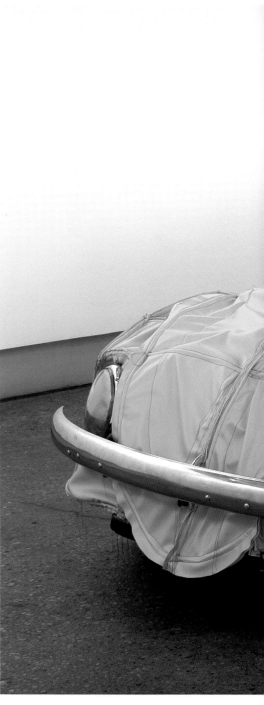

Vocho (yellow), 2004
Vinyl, thread, car parts
5 x 6 x 13 ft

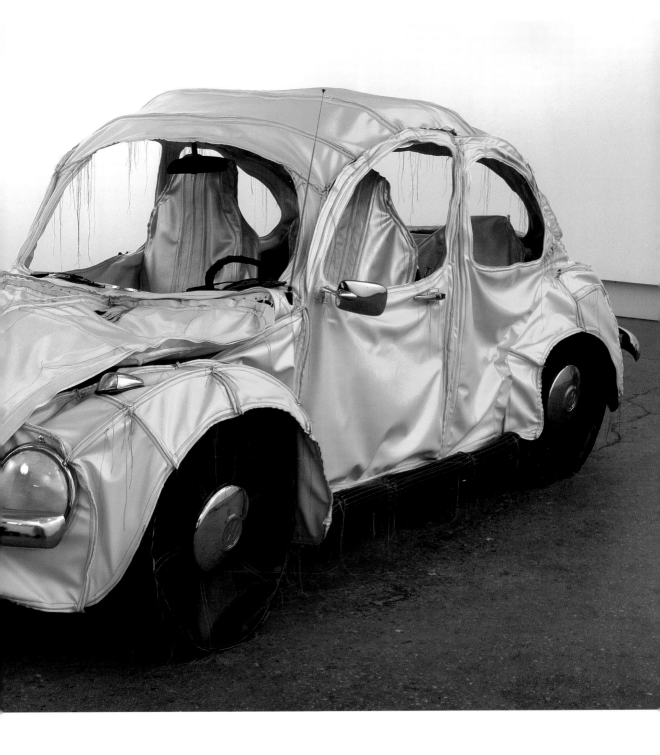

Rachel Cattle
London, England

Using elements from personal recollections of my childhood, I explore primal fears and anxieties. Influences include my family, TV programs like *Doctor Who* and *The Addams Family*, and tales of mythological creatures such as yetis and werewolves. From the unspeakable monsters that live under the bed to the witches that lurk in huts in the forest, I create pared-down drawings, animations, and sculptures.

I employ hands-on methods and low-tech materials as a knowing and humorous nod toward my childhood ways of working. Drawing has always been my main activity and I make things from materials that I find on hand.

The sculptures take time and are laborious. They feel like three-dimensional versions of my drawings, so the actual process is different but they all spring from the same ideas. A ghost is made of cloth and a difficult girl appears on a T-shirt.

The biscuits relate to the joy I had when I made them as a child. I don't really mind if things last or don't. They are photographed. In a way they are as much about the process of me making them. Biscuits are tricky and you never know how they're going to turn out. I made a batch for a recent exhibition and I was so nervous on the day that I got the recipe wrong and they looked all puffed up. It's all part of it, I suppose.

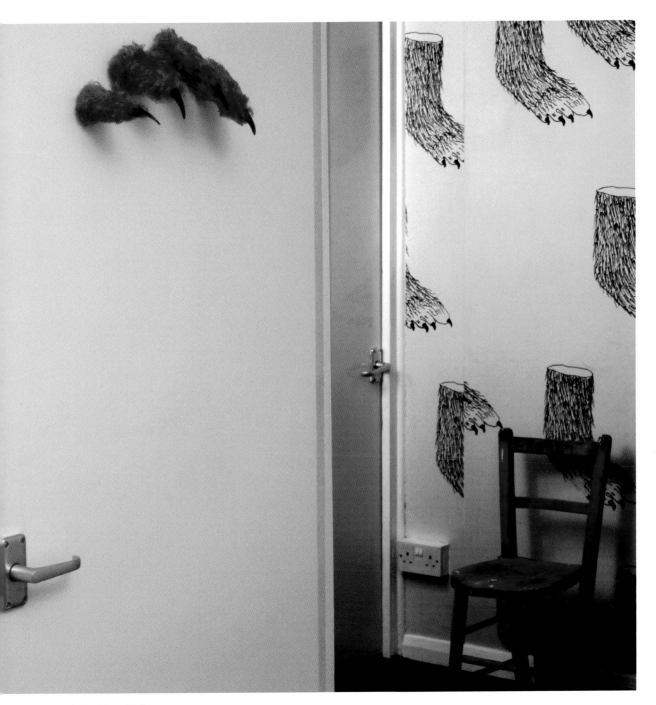

Claws and Yeti Foot Wallpaper
(installation view), 2005
Mixed media
Dimensions variable

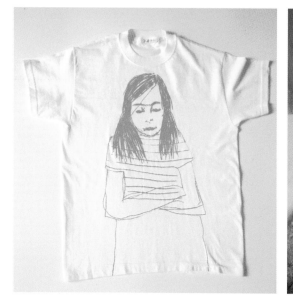

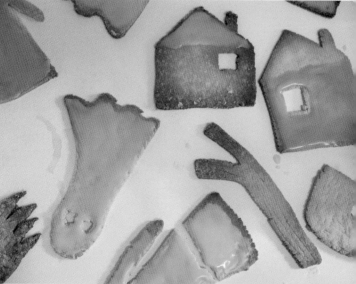

Clockwise from top left
Stripey Girl, 2004
Screen print on T-shirt
Dimensions variable

Biscuits, 2004
Dough, icing
Dimensions variable

Twigs, 2005
Packing tape
Dimensions variable

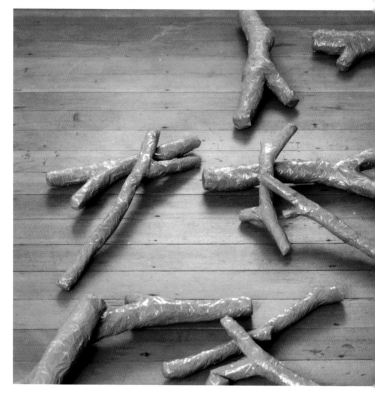

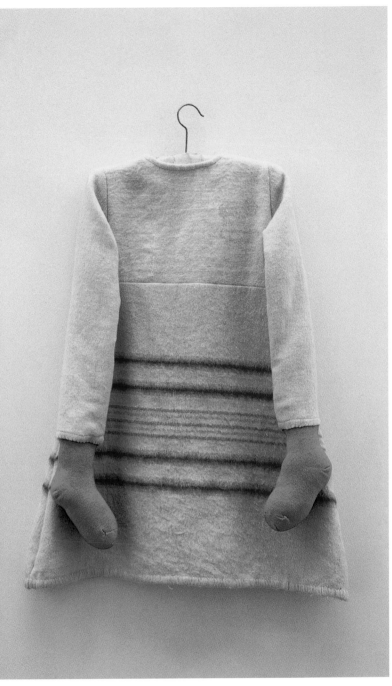

Blanket Dress, 2000
Sewn fabric
35 x 25 in

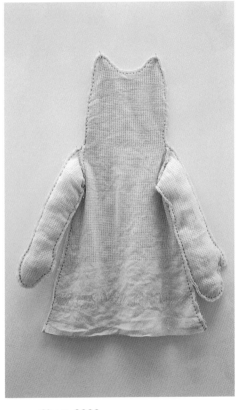

Ghost, 2000
Sewn fabric
51 x 29 in

Dave Cole
Providence, Rhode Island

I learn as much as I can about many types of materials all the time. I'm a materials nerd. I'll get an idea about an object or a form and it'll seem to work particularly well with a certain material.

Often I'll have to build a machine to process the material to make it usable. Recently, I had to build a machine for cutting license plates into long continuous strips. I took a sheet metal shear from an old WWII aircraft and ran it through the foot pedal of a sewing machine and mounted it to a geriatric cane. It ended up working perfectly for cutting license plates into long spirals of metal with which I could knit, and it became an artifact or art piece itself.

I was taught to knit when I was working at a summer job running educational seminars for teachers. A teacher who had taught her hyperactive students to knit showed me how to do it. I'd been curious about knitting, but, being hyperactive myself, I'd never had the patience to knit. She claimed that if she could teach it to seven-year-old kids, she could teach it to me. After I learned, I started knitting during lectures at Brown to help me pay attention. One day I was in a sculpture class and something clicked between the knitting and the sculpture.

I like the idea of knitting because it is a very intense, laborious process. It's the most basic form of labor that I can think of. You need tools and skills and materials, and then you process the materials into a product or an object or a component product. My sculptures require very thoughtful, hard work. They involve making swatches and then machinery, and all of this is ultimately really absurd. But there's something compelling about taking a long time to make something. The process becomes important.

A basic element of my work is that I'm subverting the feminine process. I think of it as that more than that. I'm subverting the masculine material. Often the piece gets read the other way around, but that's not the intention. It's more like I'm co-opting the domestic process to say something about masculinity.

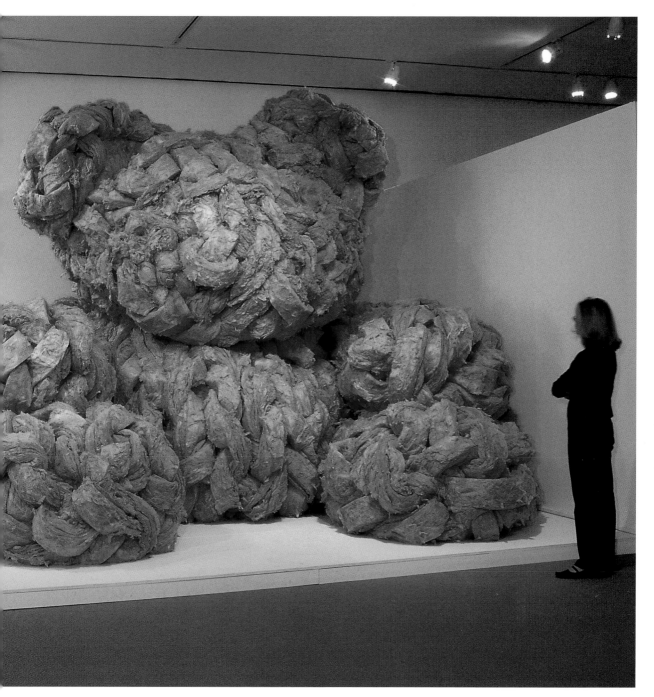

Fiberglass Teddy Bear, 2003
Fiberglass insulation hand
knit with urethane fixative
14 x 14 x 14 ft

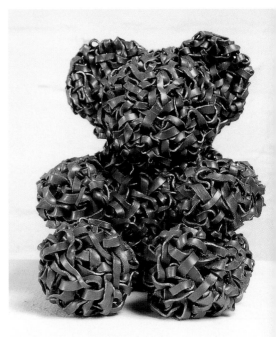

Right and facing page
Lead Teddy Bear, 2004
Lead ribbon hand cut and
knit, lead wool stuffing
5 x 4 x 6 in

Below
Bullet-Proof Sweater, 2001
3,540 linear feet of Kevlar thread
Size 42

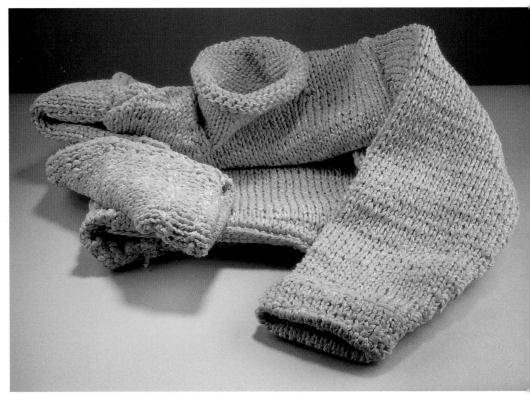

Robert Conger
Brooklyn, New York

From a completely conceptual perspective, I thought picking up a craft that I did as a child—making latch-hook rugs—and attempting to enhance it, exaggerate it, and flesh it out as an actual art piece might allow for a richer understanding of craft and my personal background.

My process has become very streamlined over the last few years. Initially, I was experimenting, fumbling, and taking stabs at creating images in rugs. Now I use Photoshop to develop a nearly correct pattern. The actual hooking is a fairly simple action that takes only a few hours to master. Creating a large rug, however, is another matter entirely. It takes a little longer, and I still haven't mastered it.

I am inspired by the odd and often dull complexity of administrative, organizational, financial, compartmentalizing institutions and systems that form a near totality of our existence. It's amazing to me how much we take for granted in the laborious paperwork and the minutiae of habits in our hypermediated day-to-day lives. I think artists have to embrace this in order to embrace humanity, or at least a humanist belief.

A few years back I made a rug not of kittens or clowns or unicorns, but of an ad of Ed McMahon and Dick Clark trying to give someone a million dollars, seemingly to erase the complexity of life and make it easier. Over the years, my focus has changed, but the inspiration hasn't. I still am fascinated and fulfilled by the idea that I can use craft to surprise people into seeing through their shields.

It is a familiar strategy to introduce a popular medium into a fine art context in a way that carefully collapses the distinction between the two. The end effect is to enable ownership of a very difficult-to-value object. Ultimately, I think it's just a great thing to have big latch-hook rugs out there. So I suppose you could call that an ontological directive. Call it therapy if you want. I don't know what art isn't.

The Big Wheel, 1999
Woven acrylic yarn on quarter-inch mesh
48 x 36 in

Powerball Line, 1998
Woven acrylic yarn on quarter-
inch mesh
36 x 24 in

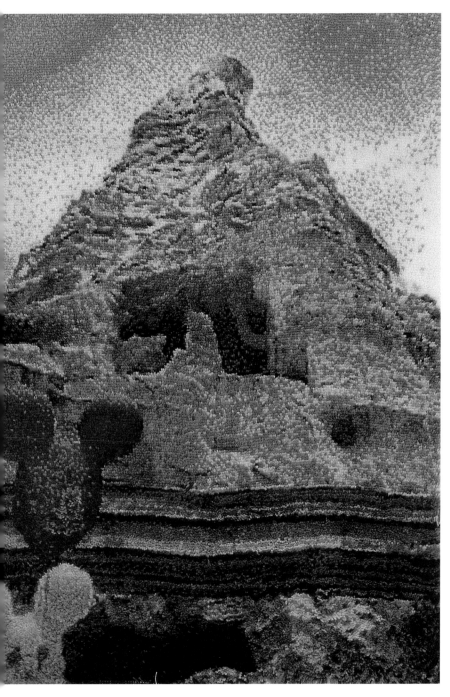

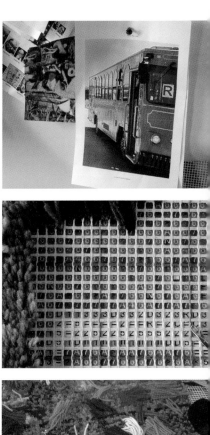

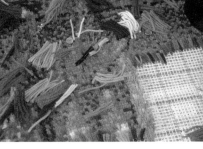

Above
Source material
Detail of mesh
Latch-hooking in progress

Left
The Matterhorn, 2005
Woven acrylic yarn on
quarter-inch mesh
46.5 x 68.5 in

Daphne and Vera Correll
New York, New York, and Berlin, Germany

For the past four seasons, we've been producing small collections of very basic garments. The materials for our pieces are really ordinary—personal, traditional materials like cotton or jersey fabric, thread or yarn, and elements gathered from generic, mass-produced clothing, like cloth collected from a bunch of faded black T-shirts or different T-shirt collars. We pay attention to the properties of these mundane materials as they're combined to form the final piece.

Once we realize a general design and method for a prototype piece—a shirt or a sweater for instance—we begin the process of recreating that piece over and over again. But each time we recreate a piece we negotiate between the very personal nature of processes like crocheting, knitting, and embroidering and the variations in the properties of the mass-produced materials we've gathered. Combining these very idiosyncratic methods and materials is necessarily dynamic, and, as a result, each line of shirts or sweaters is composed of different versions of the same idea. Each piece is intended to be in between a one-of-a-kind and a more typical reproduced item.

The act of using something—touching it, wearing it—tends to remove the sense of sacredness that other artworks carry. We like creating things that become integrated into people's lives. Clothing tends to be accepted for what it is and for the role it plays once it leaves the shelf and circulates. For us that's a gratifying way of putting our ideas out there.

As sisters, we've always had a very natural working relationship, and it was really interesting for both of us to see how the different sensibilities we'd developed could be combined. Most of the time it's just the two of us in our studio. We each spend a lot of time working individually to generate a specific piece. There's a little bit of an exchange during this experimenting phase, but we really begin working together when the basic idea of each piece is clear. For the most part, the collaborative part of our process is about editing. When we work together with an eye on the collection as a whole, that's when our sensibilities really begin to complement each other.

Sweatshirt (detail), 2005
Fabric, appliqué, stitching, screen print
Dimensions variable

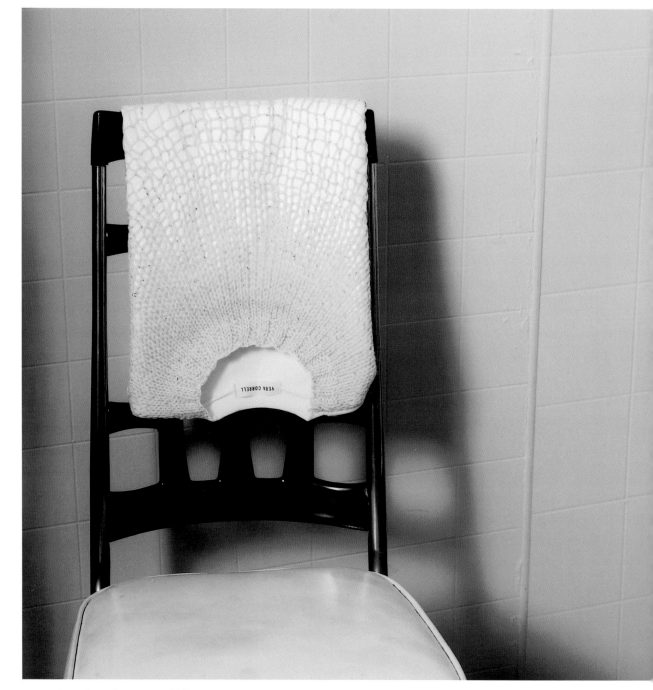

Vera Correll sweater, 2005
Fabric, hand-sewn yarn
Dimensions variable

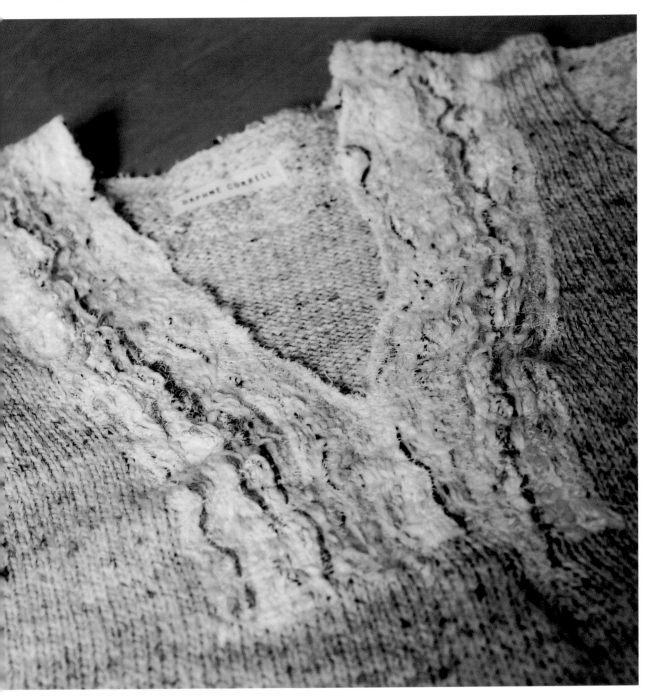

Daphne Correll sweater (detail), 2005
Hand-sewn yarn
Dimensions variable

Frederique Daubal
Paris, France

I grew up in the south of France, went to four art and design schools in France and Canada, and never attended any fashion design schools. You always have to decide between this and that, but I am pretty glad to have been a student in different schools in several cities and countries.

My work is really hard to describe. I love it, and it's deeply linked with my daily life processes. I try to stay sharp and not repeat myself in order to continue enjoying it. I work on different projects at the same time, either for clients or for myself, and it's a good balance. Ideas can come from anything, at any time.

I started working with textiles and sewing quite naturally. I was a fan of silk-screen printing and at one point I switched from printing on paper to printing on second-hand clothing. Sewing was necessary to give shape and volume to the pieces, but I didn't really like doing it.

Pieces like *Fat & Comfortable* and *Spare Arm Gloves* only serve to answer a question or give form to an experiment. I never really thought about my aesthetic; it just appeared through my process. People have called it "do it yourself," "spontaneously conscious," and "fresh chic." I suppose my work has no boundaries, but I do like to make the objects speak.

Fat & Comfortable, 2005
Fabric, thread, polyfill
30 x 20 in

Clockwise from top left
Big Hand Memory Bag, Milkyway
Jacket, 2005, Sewn fabric and plastic,
Dimensions variable; Democratic Lamp
A, Magenta Outline Dress, 2004-2005,
Sewn fabric and mixed media, Dimen-
sions variable; Various garments with
zippers, buttons, and pleats, 2005, Sewn
fabric, Dimensions variable; Sweatshirt
Coat…Your Way, Memory Bag, 2005,
Sewn fabric and plastic, Dimensions
variable

Clockwise from left
Spare Armgloves, 2005
Sewn fabric and polyfill
Dimensions variable

Pile of Fabrics Cushions, 2003
Sewn fabric
28 x 24 in

Democratic Lamp B, White
Warmer, 2004–2005
Sewn fabric
Dimensions variable

Rowena Dring
Amsterdam, The Netherlands

I have always made things. I grew up in a typical seventies middle-class English family with a mother who made all our clothes. We baked cakes and did craft activities on the weekends. I guess the moment when "things" became "art" was when they were recognized as being so by a third party, in this case my father. I had made a small watercolor using stripes of color that ran into each other. I turned it ninety degrees, and it looked like an abstract urban landscape at dusk. I surprised him and was surprised by his reaction to it. I guess I was about five.

I use photographs I have taken as source information for my drawings. I make the drawings on my computer, using a work tablet in the same way I would use marker pens. I then scale the drawings up and translate them to fabric by using a process described in most seventies craft books as "machine appliqué." A large work can take around 1,200 hours from starting a drawing to stretching the finished appliqué.

I realized that I could make paintings that masquerade as quilts and quilts that masquerade as painting. But my work isn't about blurring the boundaries between art and craft: it's about redefining painting and addressing the politics of representation in a way that is relevant to me. In swapping cotton for paint, and everything these mediums traditionally signify, I opened up a new arena for myself. I found this to be a very liberating position where I could then explore issues of visual representation and make the paintings I wanted to see without the baggage of the history of painting.

In the first appliqué works I made, I was questioning my notion of home, in England, as a British woman who grew up in the provinces. The first appliqué work was of a cottage and titled *Home*. The cottage floated on a cream background, held up as an English ideal of what a home should be. I made it after a paint-by-numbers work of Andy Warhol, who is a particular favorite of mine. I went on to make a series of "home" pieces, along with a pub, parks, seventies housing projects, landscape gardens, and follies.

Willow & Water—the Remix, 2004
Stitched fabric
88.75 x 71 in

Following pages
Big Daisy, 2004
Stitched fabric
49.4 x 31.75 in

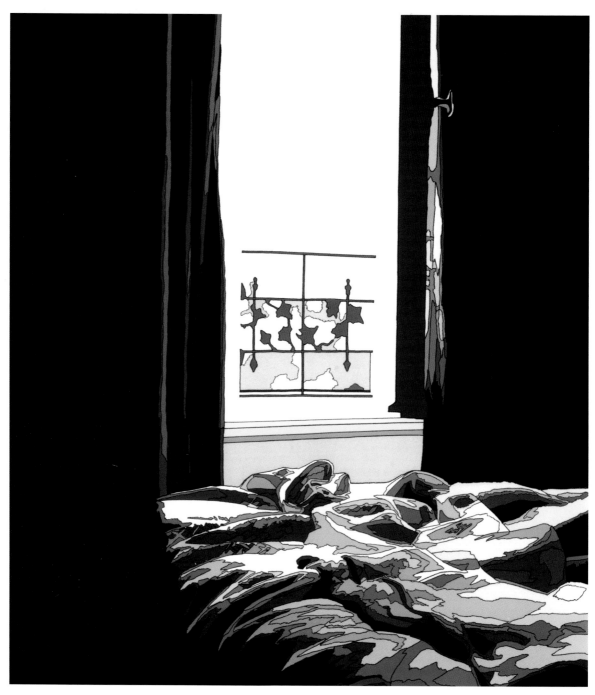

Room 01, 2004
Stitched fabric
59 x 51.2 in

Dunes, 2004
Stitched fabric
88.75 x 68.9 in

dynamo-ville

Keith Knittel and Alisa McRonald
Los Angeles, California

We met in Montreal while we were both at university. In 1997 we opened a store in New York City that was a physical location for dynamo-ville. There we held puppet shows, displayed work, and sold dolls. We were attempting to blur the lines between fine and commercial art, which is a reoccurring theme in our work.

We have always been influenced and intrigued by dolls and stuffed animals, especially the ones that were a bit "off"—the type you find at a thrift store or in your grandmother's basement. These pieces felt connected to the things we were drawing and painting, so it was a natural progression to start making dolls. The characters are created first and over time they develop their own distinct personalities. Sometimes they are so subtle that only we really know. The stories for each character evolve naturally after we've lived with them.

At one point, we were making dolls for no other reason than to fill orders, and we were saddened by the direction our work was taking. Our characters were becoming nothing more than fancy toys. Recently, we have regained balance and focused heavily on the "fine art" side of things. We have stopped selling our dolls in commercial settings and we have tried to return to concepts from the early days of our collaboration.

The themes in our work were born from and influenced by a mutual love of children's television, grandma's crafts, mythology, and animals. Our ideas are expressed through many media—painting, drawing, books, puppets, dolls, video, food, and music. In general, we work separately and side-by-side at the same time, combining the work each of us makes into a larger body. The shapes, forms, and methods that we use are familiar and comfortable, which is how we want our work to come across. By using lots of recycled fabrics and materials, the objects have a built-in nostalgia and history.

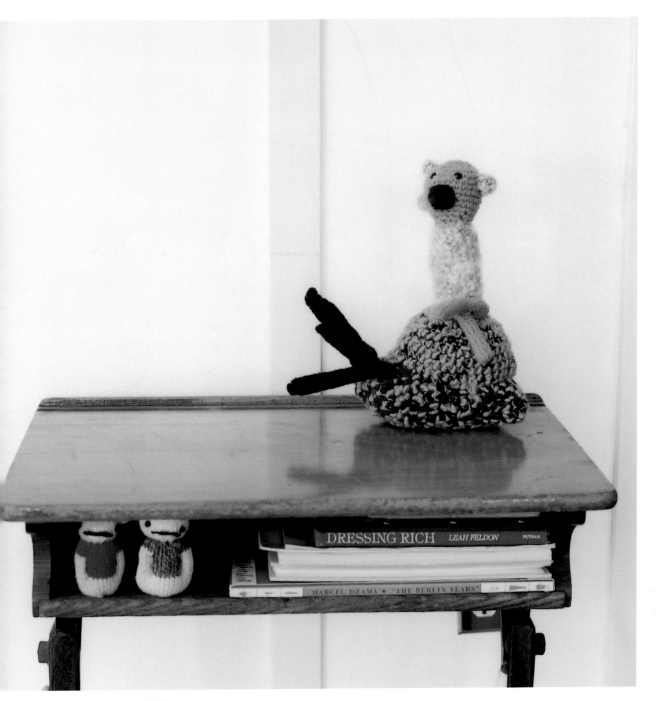

Knitted Pom Pom Ears, 2005
Yarn, felt, and pom poms
3 in tall

Right
Rabbit Dream Pillows and Cat, 2003
Canvas, thread, corduroy, felt, and velvet
Dimensions variable

Below
Knitted Pom Pom Ears, 2005
Yarn, felt, and pom poms
3 in tall

Facing page
Velveteen Cats, 2003-2004
Velvet, felt, and corduroy
6 and 7 in tall

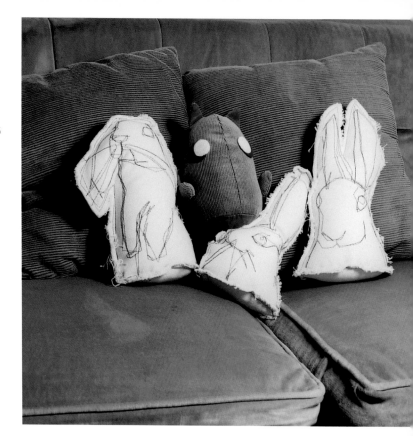

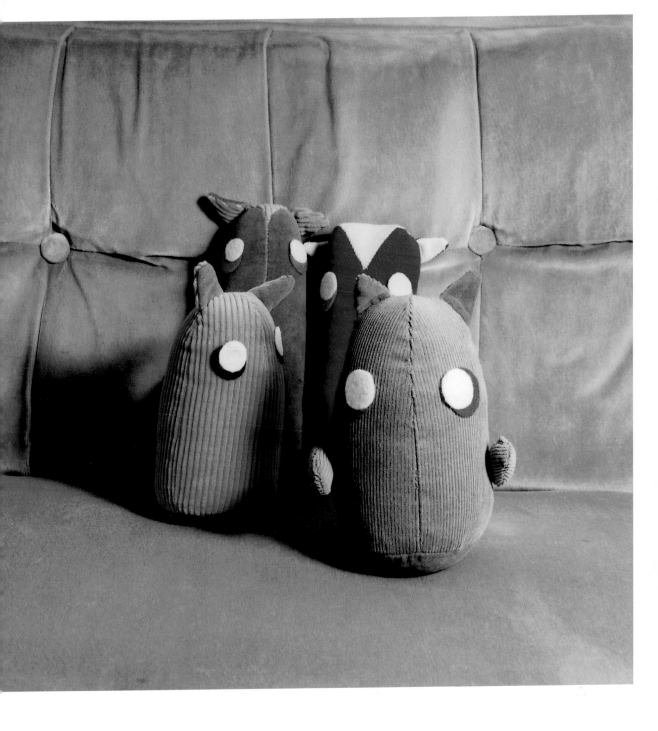

electricwig
Tim Denton and Johanna Van Daalen
Belfast, Northern Ireland

We center our approach to design around people: creating objects, spaces, or systems that benefit the user. Our *Padded Socks* came from working on a project for children with disabilities. The intention was to create an object with a child that would reflect the child's own needs. Wendy, the girl who Johanna worked with for the project, wanted to make something for her support assistant who had to spend much of her time on her knees helping Wendy. The socks were intended to help take the strain away from kneeling, but I think that the main reason for the design was to have a laugh at her assistant's expense by making her look stupid when wearing them.

The *Muji Mook* was our response to an invitation from the Muji company. We were asked to alter an existing item bought from their shop. The English and Japanese share a similar obsession with tea. This is something that we wanted to explore with a typical Japanese tea set by creating a tea cozy, which is a typical English object, for it. One way of creating a tea cozy is by using recycled threads and knotting them together to reknit a new item—this was done during the Second World War when there was a shortage of materials. In today's culture we seem to have too much material; for our tea cozy we used a recycled sweater.

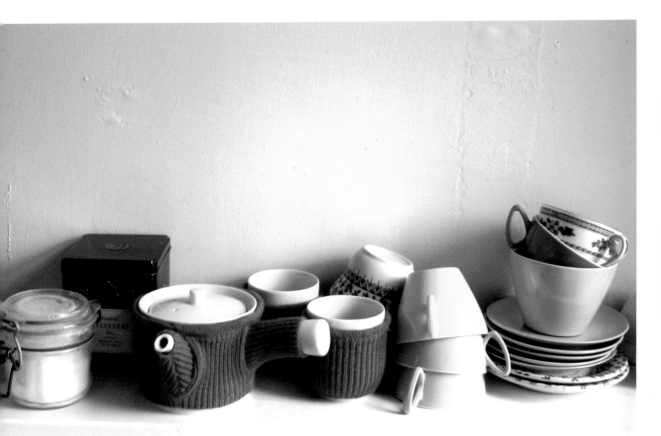

Muji Mook, 2004
Sewn recycled sweater
Teapot: 4.35 x 3.15 in; tea cup:
2.35 x 2.35 in

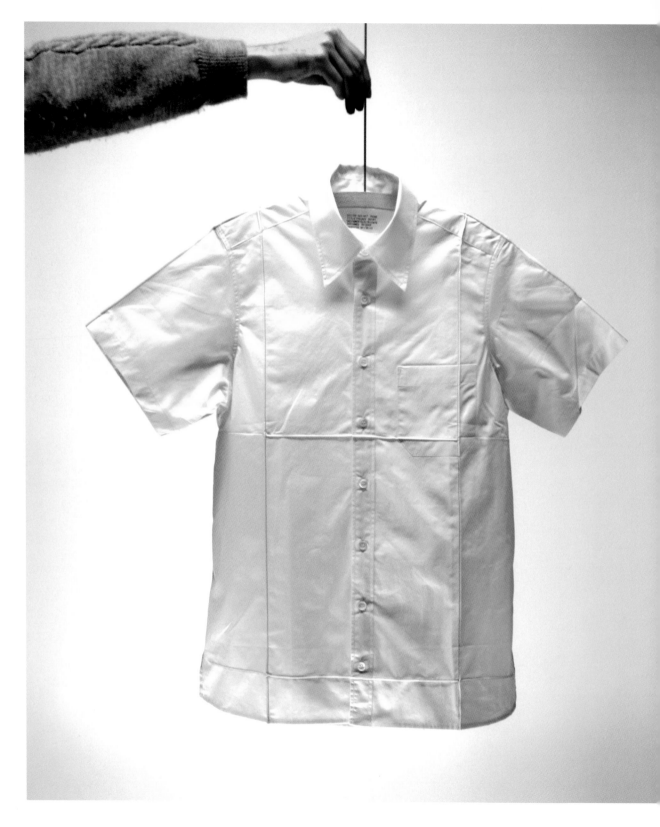

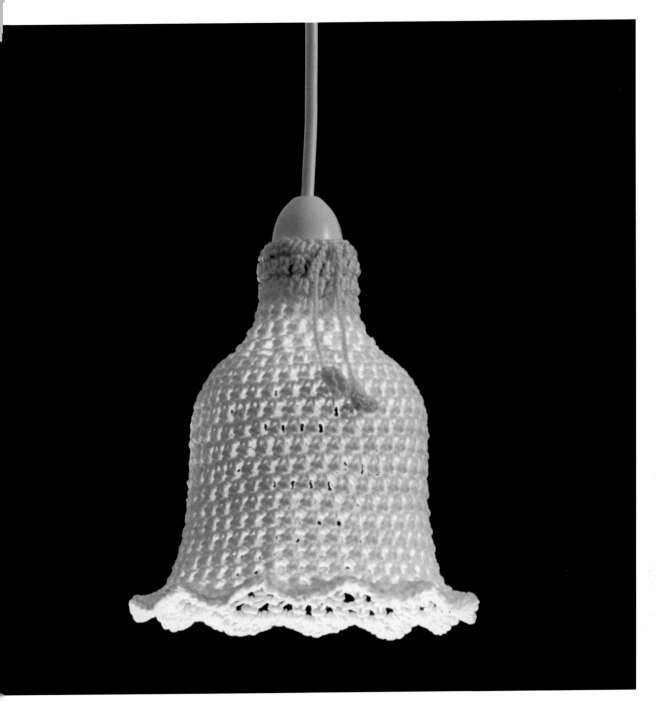

Above
Crocheted Lampshade, 2002
Cotton, sugar water
5.75 x 5.75 in

Left
Perfectly Folded Shirt, 2002
Sewn fabric
Dimensions variable

Above
electricwig idea board

Right
Padded Socks, 2004
Knitted yarn
Dimensions variable

Facing page
Warm Hands Cushion, 2005
Sewn fabric, polyfill
13.4 x 13.4 in

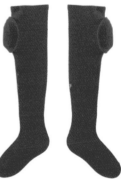

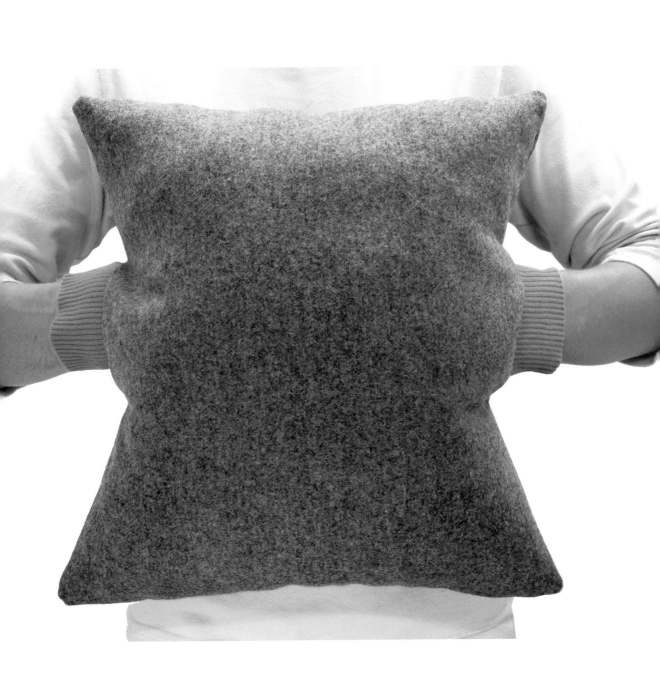

Evil Twin Publications

Stacy Erin Forté
Livingston Manor, New York

Evil Twin began as a collaboration with my twin sister, Amber Gayle, in 1994. We were both in Amsterdam and reading a lot of zines that a friend, who was touring with a band in the States, was mailing to me. We were inspired by the intimacy and immediacy of the zine genre and wanted to dive into that. I started making zines with my sister and we distributed them through Factsheet 5 and Zine Stuff. At the same time, we were working on our first limited-edition artists' book, *Transient Songs*, a book of Amber's poetry and my photos. So those two projects were finished at about the same time and propelled us into the book world.

A lot of things are mass produced and don't need to be at all. People make cheap looking books where the design decisions look clearly based on their cheapness. Sewing books yourself is also cheap, and it's satisfying and makes the objects more special. Everyone who buys one of our books can feel that we have touched it and in that way blessed it. Books are little worlds that you enter. They can be so private and rich. You can be on an airplane but lost in a seventeenth-century royal-court drama—it's just completely magical. So I try to think of ways to make our books unique and delightful, so people who buy them and spend time with them can really feel the presence of the person who made them.

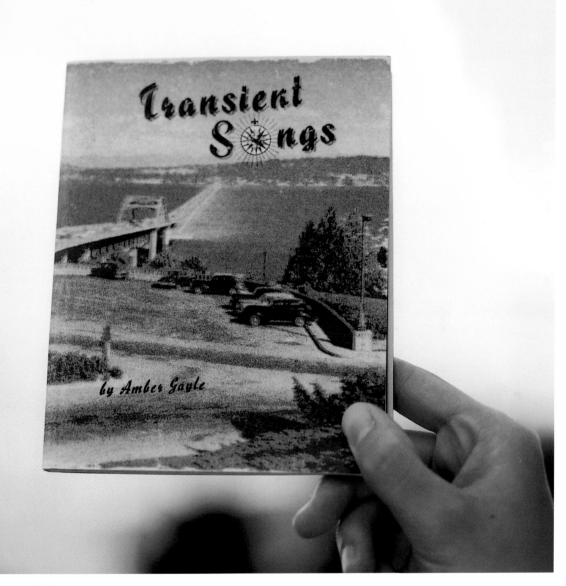

Transient Songs, 1994
Hand printed
4.5 x 5.5 in

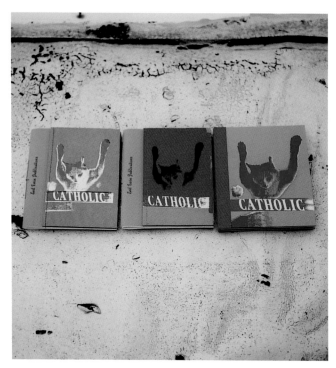

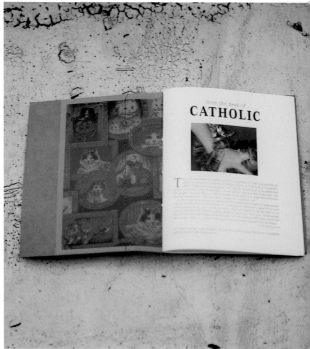

Catholic, 2004–2005
Limited edition: offset printed, hand screen-
printed cover (two versions), stitched binding;
trade edition (published in cooperation with
DAP): offset printed, screen-printed cover,
perfect binding
7 x 8.5 in

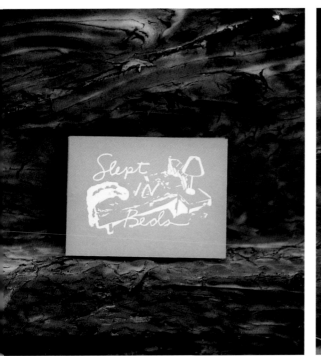 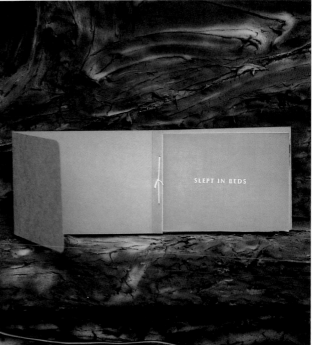

Slept in Beds, 2003
Screen-printed paper and fabric with
tipped-in glossy photos, hand-sewn binding
8.25 x 5.75 in

Tess Giberson
New York, New York

Textiles are an integral part of my work and one of my most important tools. Weight, feel, content, texture, and pattern are carefully considered and chosen to work into the concept. I have a fascination with surface and texture and experiment to push materials into unexpected directions through stitching, piecing, embroidery, and removing fibers. However, I always respect the original nature and listen to the fabric.

My collections are concept based. Beginning with the presentation, I work backward to create an environment to express the idea. Once I know how the show will look, all other elements—from color to fabric, silhouettes to details—are developed to support the end result. Consistency and cohesion are essential to my work.

The hand is important in the experimentation stage, as there is a level of intricacy you can only achieve when the hand is directly involved. However, once I know what I want I can easily pass this on to be executed by others. I prefer to think of the larger picture and not get stuck only in the making.

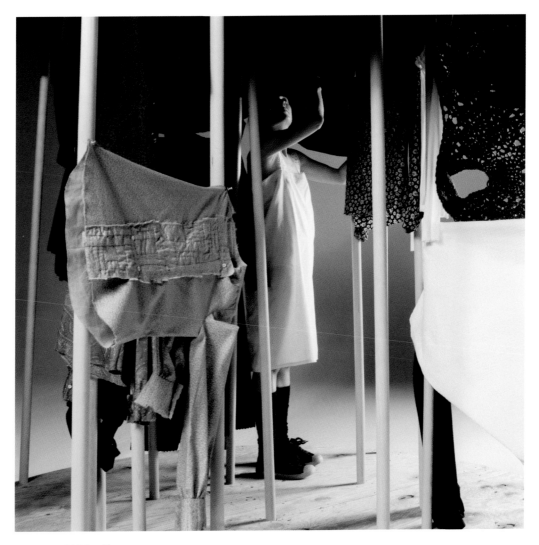

Fall 2003 collection
Sewn fabric
Dimensions variable

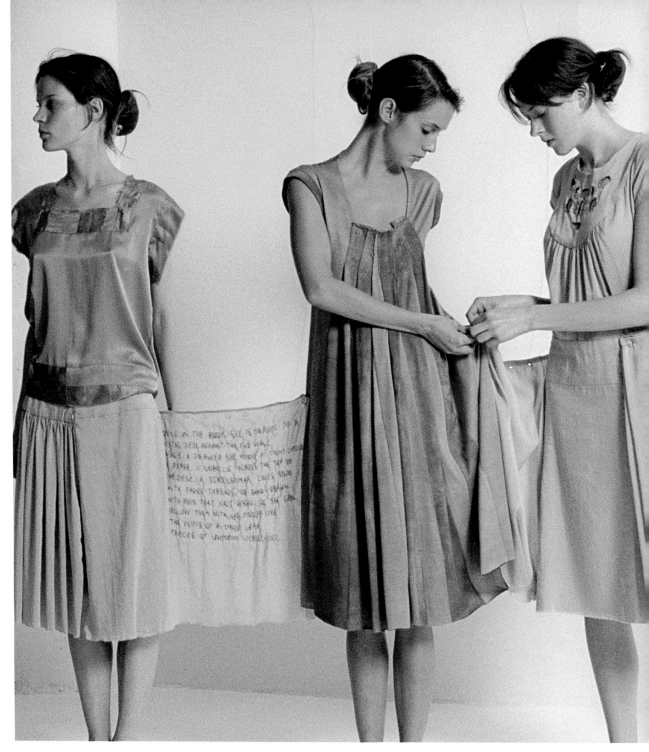

Connection, spring 2004
Sewn fabric
Dimensions variable

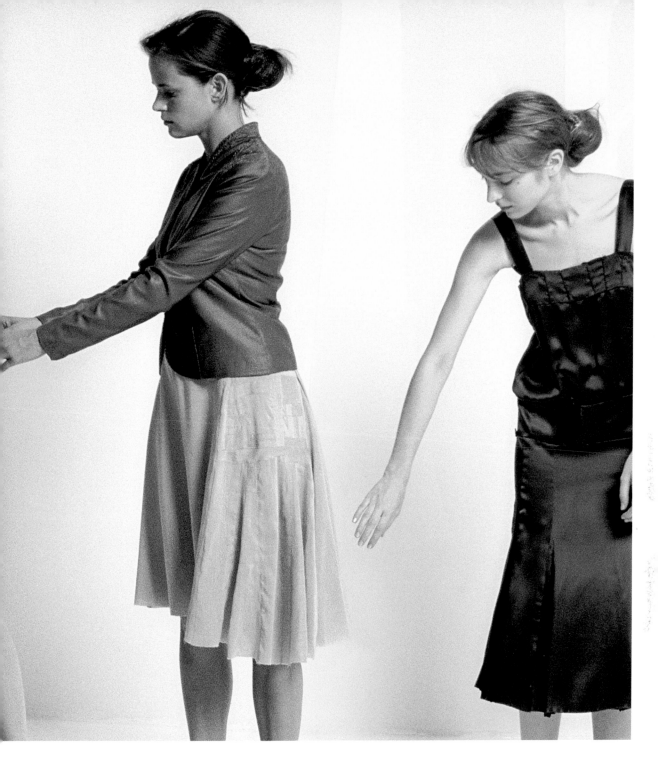

Kirsten Hassenfeld
Brooklyn, New York

My work has evolved into a three-dimensional daydream in which my ambivalence toward material wealth and privilege is expressed. Precious objects speak about the cultures that produce and consume them. I revamp these objects with decidedly un-precious materials and varying scales, making fantasy tangible in a manner that calls into question what is considered precious.

Luxury goods are paradoxical; they can be acquired with money, but we think of the status they connote as beyond money's reach, like privileged ancestry. These objects position identity as decoration, family pedigree as brand. The notion of the birthright is both fascinating and repulsive, collapsing what we have with who we are.

My sculptures, as they reference specific markers of status, are themselves part of a larger economy of privilege. Contemporary art is, in the most extreme way, a luxury. My artwork self-consciously acknowledges its own extravagance and impracticality.

My process is very intuitive and unplanned. I usually start to make something with a vague notion of what it might be, but I go off in a different direction by the end. The lighting is the "magic" in my work. Without it, all the detail and the effects of translucence against opacity, which create the intricacies in the work, would be lost. Looking at an object that is lit from within has a hypnotic effect on people, like staring at a fire, a TV, or a stained glass window. Light causes objects to visually dematerialize. This is in keeping with my desire to create objects that seem to be dreams on the edge of vanishing.

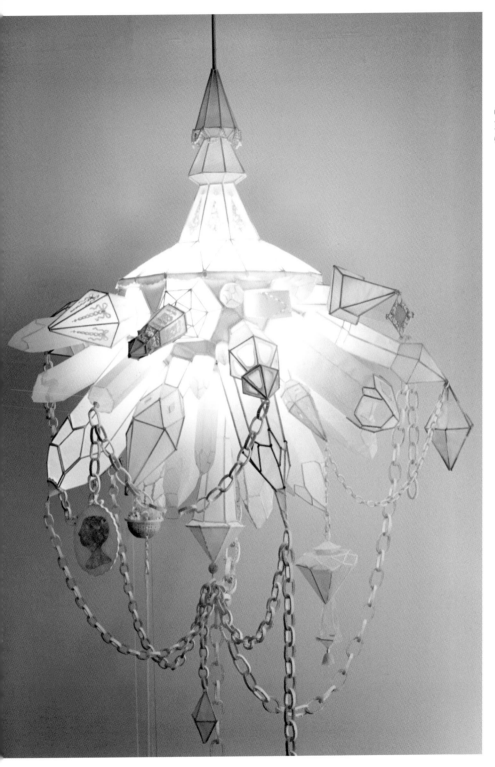

Crystal Chandelier, 2004
Mixed media
60 x 24 x 24 in

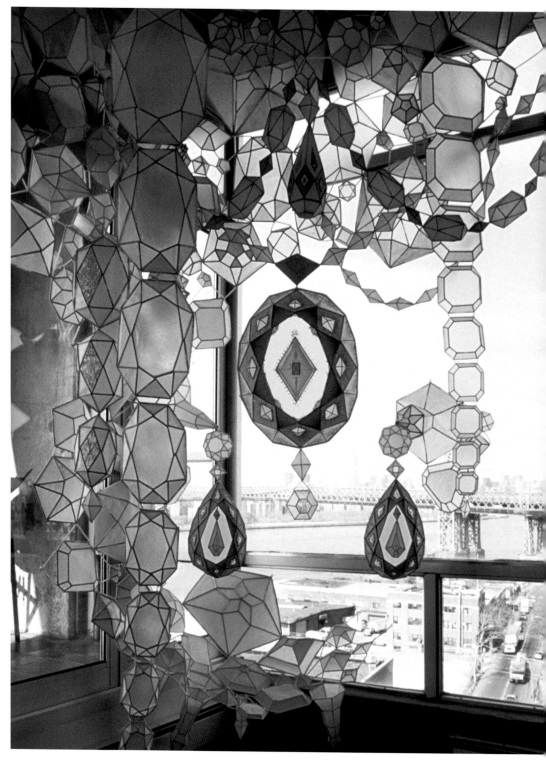

Parure, 2003
Mixed media
20 x 15 ft

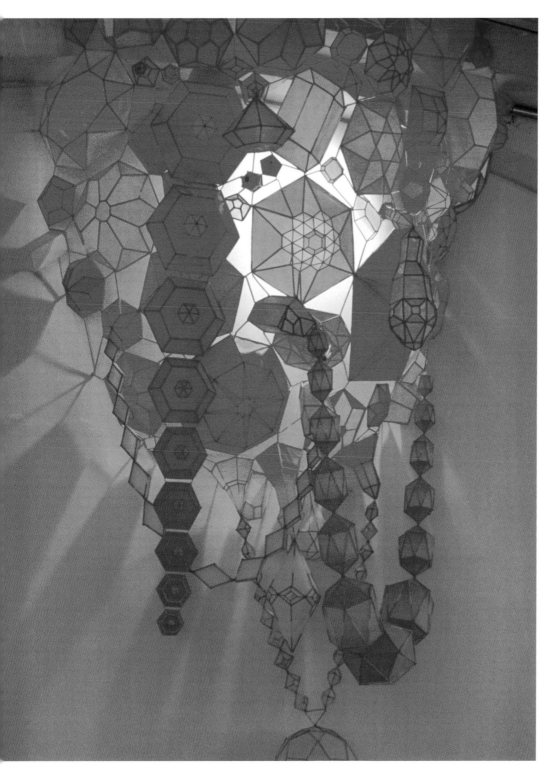

Pink Cluster, 2003
Mixed media
8 x 6 x 4 ft

Kent Henricksen
New York, New York

My work mostly involves embroidery and textiles. I embroider ropes, hoods, and costumes/robes onto both found fabrics and textiles of my own design. The found fabrics are Toile de Jouy. The imagery depicts young lovers picnicking or children playing in a park. To these scenes I embroider hoods and ropes, turning light-hearted innocence into dark vignettes of sadism and emotional aggression. The designed textiles are created by first silk-screening images onto linen and cotton fabrics, and then embroidering specific sections of the design. The images are my own drawings based on children's games of imitated adult behavior. Instead of cops and robbers, the children play prisoners and executioners.

I traveled through Southeast Asia for about a year without making any art. There I saw many indigenous tribes living and struggling to survive. The Burmese refugees living in Thailand, the hill tribes of northern Vietnam, the Hindu and Muslim peoples of Indonesia—all were and are a constant source of information for me. When I got to New York, I started making pen and ink drawings of these people, most specifically of the Tamil Tigers. The Tigers are also known as the Liberation Tigers of Tamil Eelam and are struggling for independence and trying to maintain their own culture and land. I wanted to use a traditional technique to express and narrate their story. Embroidery has been used to tell stories of warriors and gods for centuries. I embroidered some of their soldiers, mostly the hooded suicide bombers, on canvas and paper.

The materials I use have a very strong affiliation with craft. Embroidery and textiles are very innocent and ordinary media used more for decoration than fine art. But, I don't consider embroidery a craft. To me, it's a similar medium to paint or charcoal as it acts primarily as a vehicle of expression. My work is more about the ideas that are produced, rather than the actual materials. I think it's very exciting to have a delicately embroidered image of a boy fucking a sheep, for example, rather than an overpowering painted image.

Country Life (Red), 2004
Embroidery thread on printed
fabric mounted onto wood
54 x 44 in

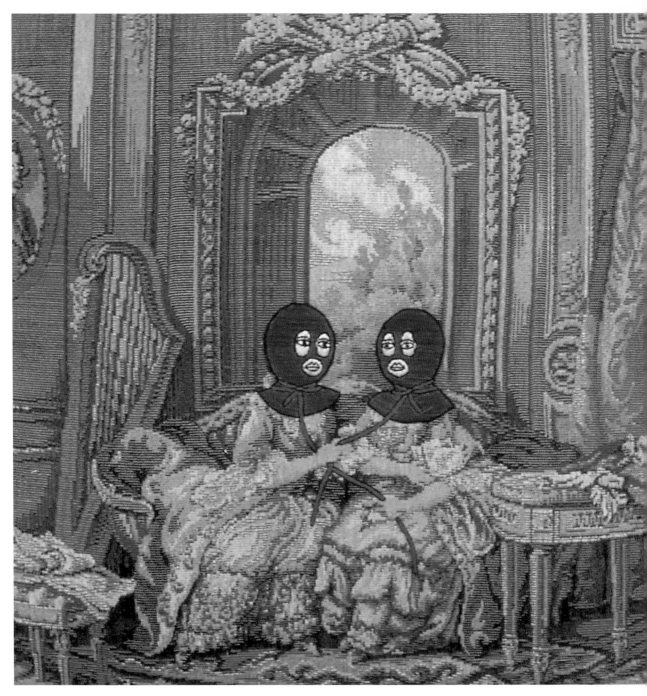

Lady Lovers (The Secret), 2004
Embroidery thread on woven
fabric mounted onto wood
18 x 18 in

Studio overview

Villain in the Water, 2004
Embroidery thread on canvas
17 x 6.25 in

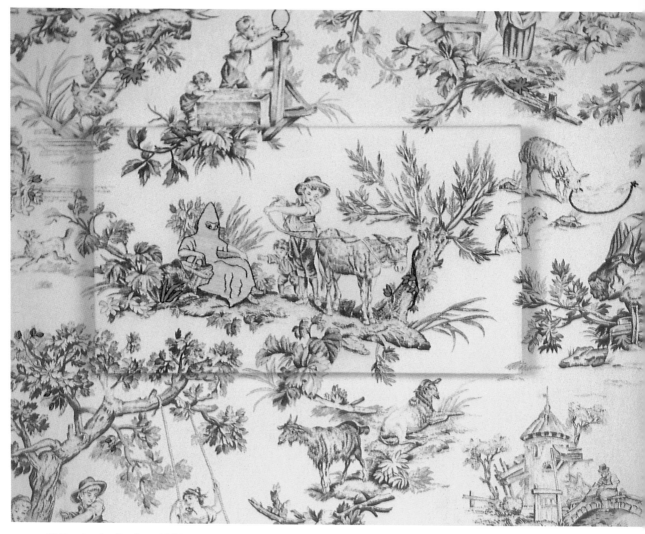

Sitting in the Bushes, 2005
Embroidery thread on printed fabric
36 x 24 in

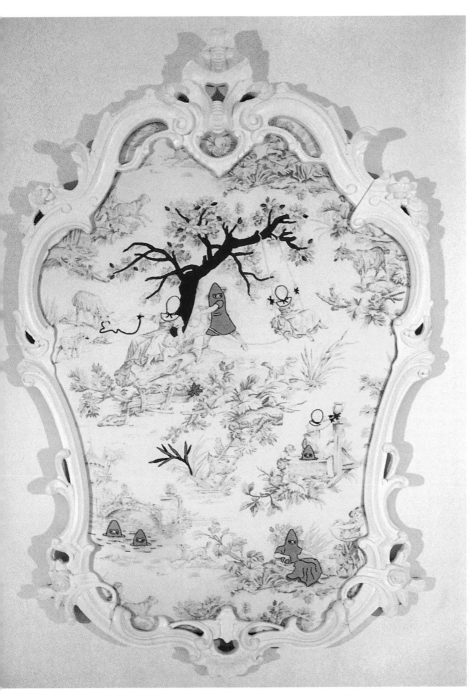

Country Life (Yellow), 2004
Embroidery thread on printed
fabric mounted onto wood
36 x 48 in

Barb Hunt

Corner Brook, Newfoundland, Canada

I learned how to knit and sew as a young girl, but like many other students attending art school in the 1970s, I realized that this was not considered "art." After graduating, however, I started to include textiles and sewing into my work more and more. I spent a year at the Banff Centre for the Arts, working exclusively with textiles in an open, experimental way. For the first time, I met people who called themselves "textile artists," and I felt like I had come home.

I am a pacifist, a heritage that I received from my family. Prior to beginning my antipersonnel land mine project, I knitted a replica of a semiautomatic rifle as a gift for Kim Campbell. She was the Canadian Minister of Justice (and later our Prime Minister) who initiated gun-control legislation. I had been active in the gun-control movement for a while. Later when I learned that Canada had initiated the Ban Mine Treaty, I thought of knitting an antipersonnel land mine. This became a reality when I was in Paris, on a three-month residency sponsored by the Canada Council for the Arts. I attended the "Pyramid of Shoes," a yearly event where Parisians leave pairs of shoes (tied together so they can be later given to charity) in solidarity with those who have lost limbs because of land mines. There were displays of information about the land mine issue. Learning more about them and seeing signs of war in Paris motivated me to begin this series.

Knitting has traditionally been used to make garments that protect and warm the body, quite the opposite of land mines, which destroy the body. I think of this as an "amnesty" project—the real mines can be traded for these ones that are soft and cozy, that would do no harm. There is also a huge contrast between the slow loving care associated with the knitting process and the instant devastation of a mine. Women used to knit bandages for soldiers, and I feel there is a link between this and my work. I am trying to communicate the precious value of the human body. That is part of the reason for my choice of the color pink, as it has strong associations with the body. I also like the association of hand-knitting with the home, a place of security. Antipersonnel land mines cause the maiming and deaths of many innocent civilians near their homes, so I hope that my knitting will make a connection to the horror of this situation.

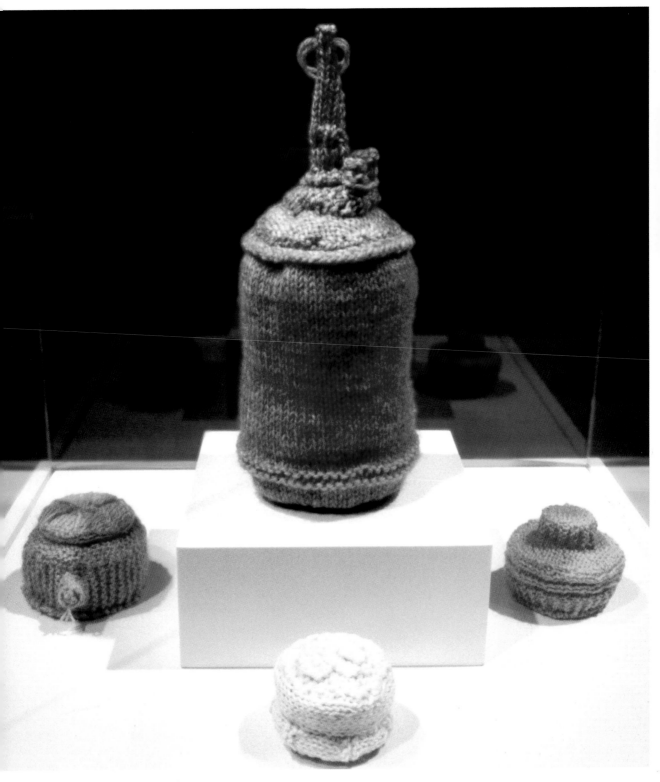

Antipersonnel (small case with
Netherlands NR-23), 2002
Knitted yarn
Dimensions variable (life-size replicas)

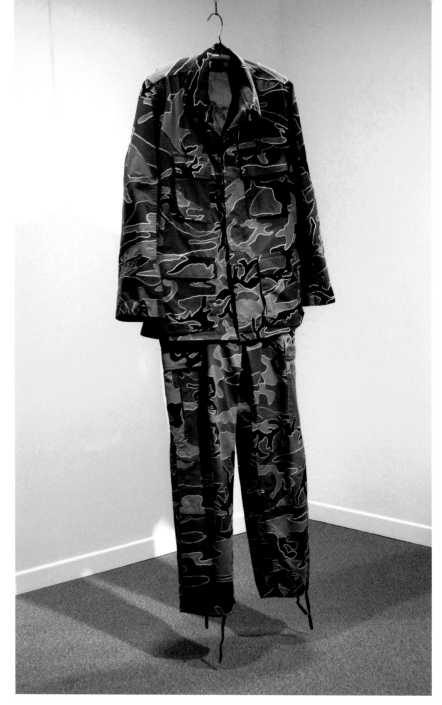

Incarnate, 2001-2004
Used army fatigues, embroidery floss
18 x 60 in

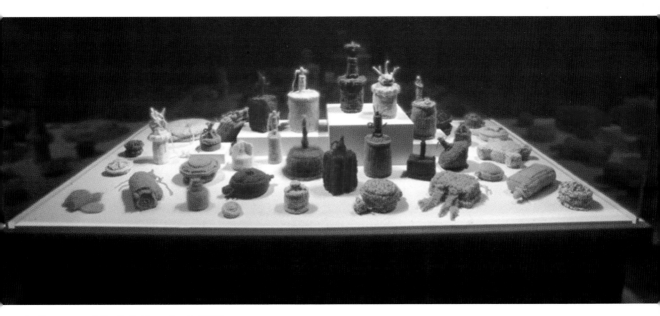

Antipersonnel (installation view), 2002
Knitted yarn
Dimensions variable (life-size replicas)

Aya Kakeda
New York, New York

My work is always somewhat narrative. Sometimes the story is obvious, sometimes it's hidden in the background. I start out thinking up a story and come up with the best media for the idea. Some of my stories are pretty violent and creepy in a dark, fairy-tale kind of way. Embroidery feels familiar, like something that has always been around your grandma's living room. I like the contrast between the violence and that soothing familiarity. I like embroidery because it's not as clean as painting. When I paint I tend to get over-obsessive with the sharpness of my lines; I feel like they have to be perfect. With embroidery I can play around more. I like to integrate the accidents in the work. I don't even have to sketch first.

I've always loved making books. When I was small I often made my own books with silly stories. I got seriously into book making when I took a class with David Sandlin at New York's School of Visual Arts. My most recent book is called *Mickey Virus*. It was made for a book show at the Flux Factory in Queens. The story is "written" on a thin scroll that pulls out of the papier-mâché head of the main character. It was all embroidered on a one-and-a-half-inch ribbon.

The characters in my stories always have a purpose. Sometimes they are metaphorical, sometimes they're inspired by my experiences. I usually come up with them while doodling on my bed. Everyday things can inspire them—like my pet caterpillar Imochan or the star nosed-mole from the *New York Times* science page.

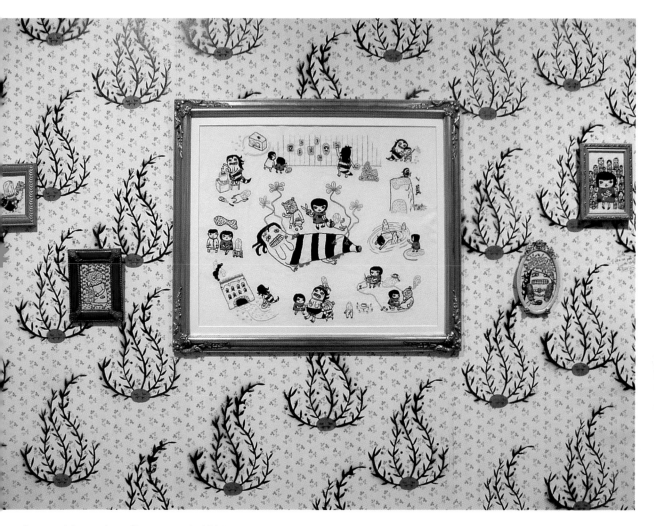

Cute and Scary (installation view), 2004
Embroidery on fabric
Dimensions variable

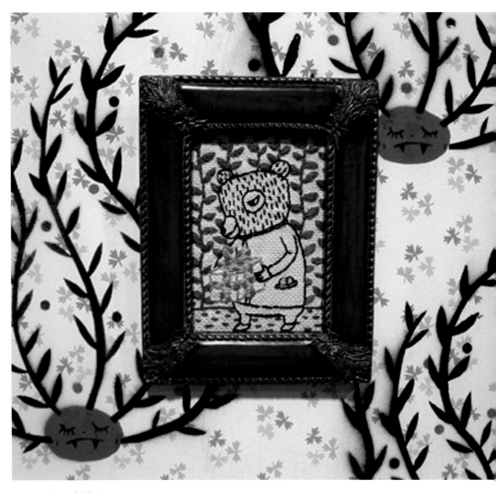

Jojo, 2004
Embroidery on fabric
6 x 7 in

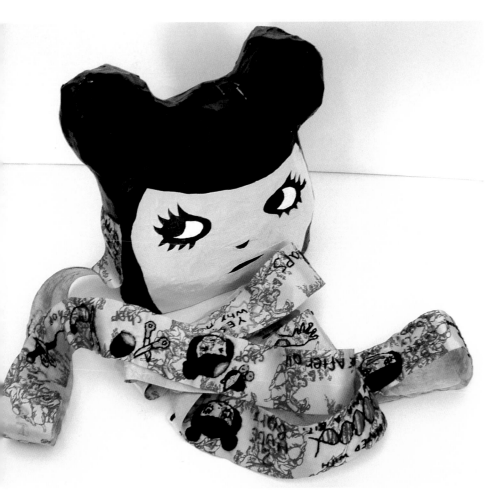

Mickey Virus, 2004
Embroidery on printed
fabric, papier-mâché, paint
8 x 7.5 in

Andrew Kuo
New York, New York

The scenes I depict are iconic environments. They include forests, mountains, skies, and haunted castles from movies I have watched and books I have read. Forests are stereotypically places of wonder and fear, while the sky holds enlightenment, and mountains represent journeys of some sort. Castles to me have always been spaces for nightmares. Memory, fear, insecurity and optimism are all themes explored in my work.

When I was young, I would copy old baseball cards with markers and put myself in the background. I think I was seven or eight years old and probably really weird. Now, I make semiabstract works on paper and wood, as well as hand-printed books.

Screen-printing allows me to layer, hide things, reveal them, and create a story with each successive pass. I'm not against using machines, but I believe that hand execution allows you to spend time with what you're making. There's an investment when you create something slowly, and that message comes across just as much as color, content, and form. In the future, however, I anticipate making small editions with a laser cutter or a stamp. And I'd like to create things with motion. Bigger things. Right now I still enjoy working on small projects, books, and zines.

Above
Maze (detail), 2003–2005
Acrylic silk screen on paper
480 x 21.5 in

Right
Angry Room (part 2), 2005
Acrylic silk screen on cut paper
15 x 19 in

Previous page
Angry Room (repeat), 2005
Acrylic silk screen on cut paper
19 x 22 in

Temporary Residence, 2005
Acrylic silk screen on wood
9 x 12 in

Robyn Love

Queens, New York; Gillams, Newfoundland and Labrador, Canada

I have been knitting most of my life—my mother taught me when I was a girl and I knitted on and off until my early twenties, when I started to really concentrate on it along with sewing and other needlework. It was the time right after I left art school. I was struggling with coming to terms with what I had learned in school, where I was led to believe that the only real art was painting. Secretly, I was knitting and making embroideries that I considered art, but I did not feel confident about showing them to anyone. The first time I did show a former professor, he laughed at me. Then, I saw an exhibition of works by Elaine Reichek at New York University's Grey Art Gallery. It was a revelation!

In the series of cozies I knitted called "Memorials" I covered parking meters, a bus schedule, and a World War I memorial. The series started after I knitted a cozy for a gravestone in a cemetery in Newfoundland. Each piece was installed, documented, and removed usually within an hour or two of being placed. This came after many weeks, sometimes months, of work to make the cozies. I was interested in how memorials are imperfect and incomplete, just like our memories. My cozies were intended to obscure the thing that was already obscuring the original person or event. They also functioned as ways for the living to still be relevant to the dead being remembered. The process of creating the work—working very intensely at a kind of work that is often described as "mindless," then a kind of cumulative experience with the installation, followed by a memory—matched the idea and mimicked a cycle of life and death. This included feelings of anticipation, frustration, boredom, excitement, euphoria—even a sense of loss when the work came down. Now, I have my nostalgia about the pieces, which I look at in photos and about which I reminisce.

I am fascinated by the craft and do-it-yourself booms, as evidenced by entire cable networks devoted to them and things like the scrapbooking craze. I think they are a result of people having no place in ordinary life to work with their hands anymore. We used to have to make our own clothes, build our own houses and furniture, preserve food, bake bread, and, in general, keep busy with our hands. Now, those tasks have all but been eliminated, but there is still the human need to create.

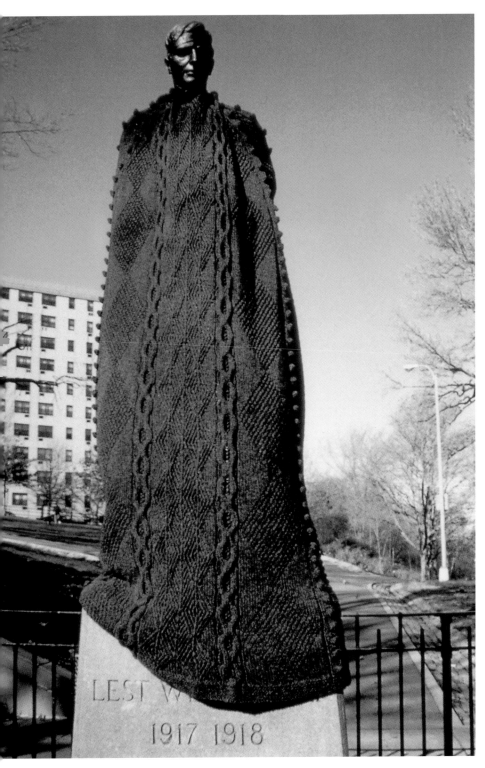

LEST W
1917 1918

Memorials: The Doughboy
(installed in Doughboy Plaza,
Woodside, New York), 1999
Knit wool
90 x 100 in

Memorials: Parking Violation (installed on
Woodside Avenue between 62nd and 63rd
streets, Woodside, New York), 1999
Knit wool
12 x 24 in

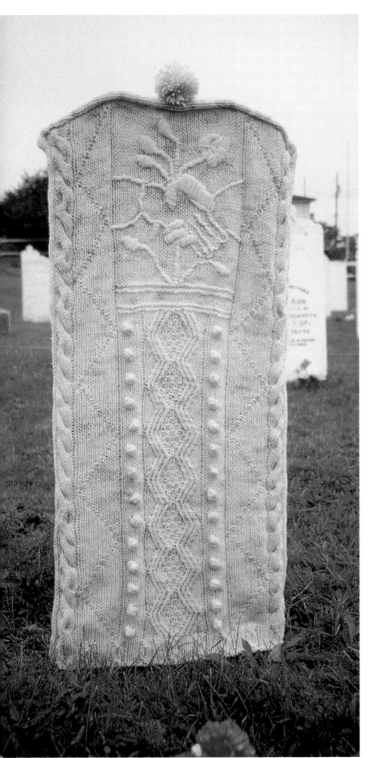

It's Cold Outside (cozy for Richard
Noseworthy, died 1963, Pouch Cove,
Newfoundland), 1997
Knit and embroidered wool
42 x 25 x 3 in

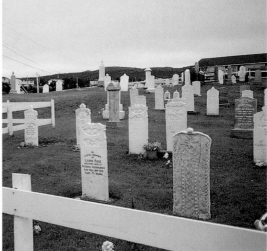

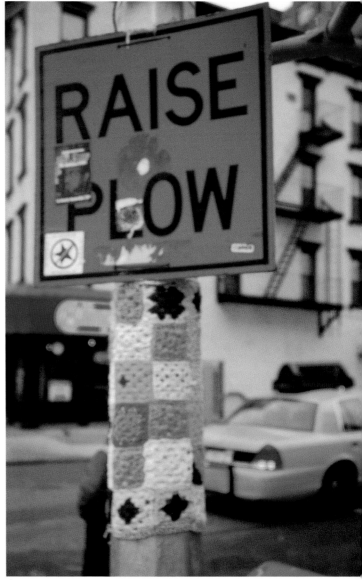

Left
Work in progress in studio

Above and facing page
Standing Still (installed along Canal Street,
New York, New York), 2002-2003
60 blankets of crocheted wool and acrylic yarn
Dimensions variable

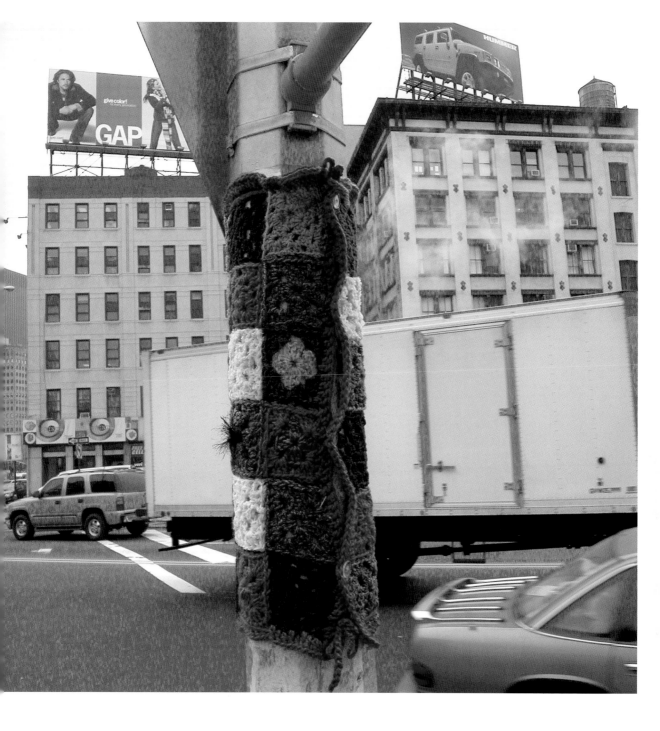

Victoria May
Santa Cruz, California

I began learning to sew when I was nine, when my father presented me with the Singer Featherweight that I still use today. My mother sewed, and thus I had an in-house teacher. My father was also very encouraging and took me to special fabric stores in L.A. The experience of being in a fine fabric store is still very seductive for me.

After I finished school, I fled L.A. and moved to Santa Cruz. Almost immediately I landed a job at a bridal boutique as a stitcher, since that was my most marketable skill after a university education. Talk about challenging! This is where I honed my sewing skills and learned custom fitting, which later had a strong conceptual influence on my artwork.

The shirt with the rows of sand came from my desire to illustrate the idea of heaviness as a comfort. The physical sensation was that of a lead dental vest. I wanted to simultaneously display a prim exterior while giving away a vulnerable interior. This is where custom fitting came in. In this case, the idea was to tailor a garment to suit one's psychological needs versus those of the body.

It can take up to forty hours to make some of my work. That's not even counting the hours of researching materials and processes before settling on a technique. Though the laborious processes can be frustrating at times, the work is soothing and can be meditative.

I choose the materials for the shirts for their metaphorical value. It is often their very delicacy that I cherish, which also makes them challenging to work with. However it is also very satisfying to merge the delicate with the strong. The materials require a lot of patience: cleaning individual chicken vertebrae, quilting around seven bits of glass at a time, figuring out how to suspend razor blades in folds of organza. Through a concise and careful use of humble materials I hope to reveal their preciousness and evoke a respect in the viewer for that which is considered ordinary or abject.

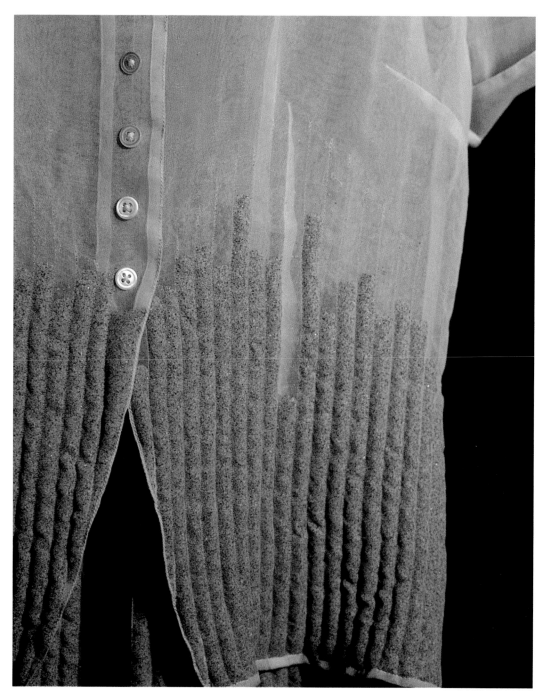

Comfort, 2000
Handmade organza blouse, sand,
steel stand
20 x 56 x 9 in

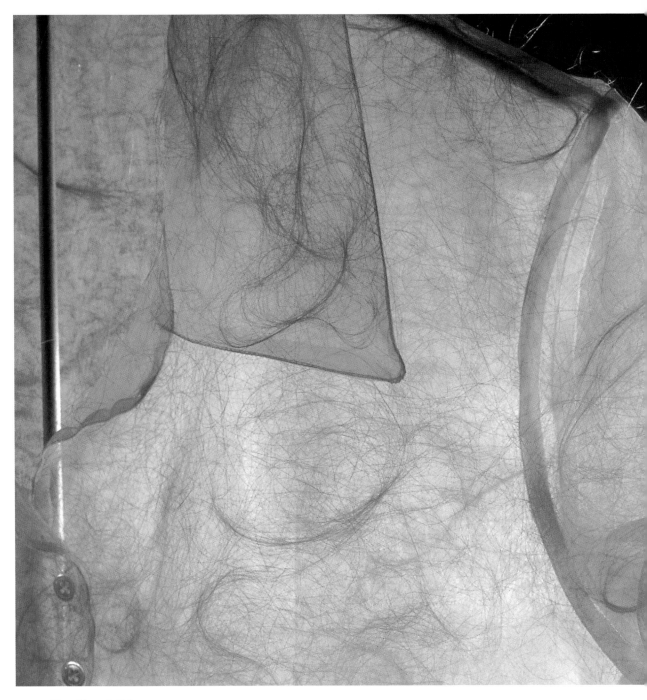

Hair Shirt, 2000
Handmade organza blouse,
artist's hair, steel stand
56 x 20 x 9 in

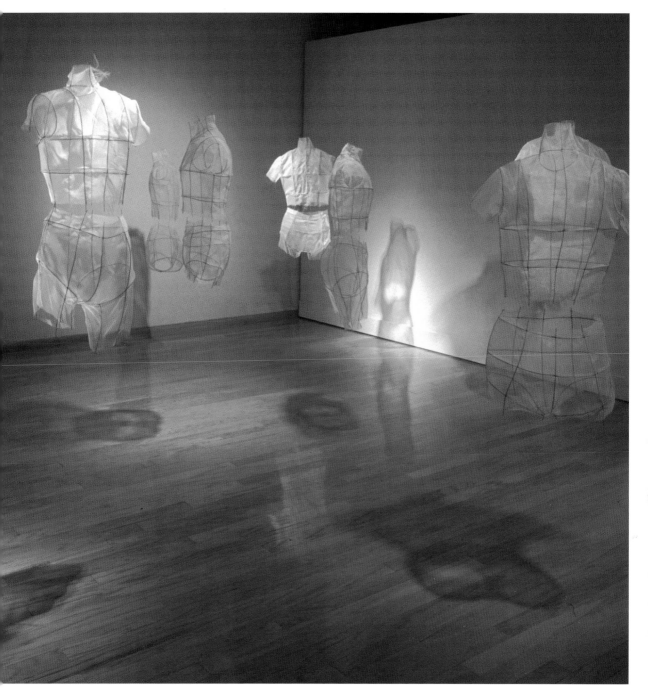

Periphery of Experience
(installation view), 2004
Mixed media
Dimensions variable

Brendan Monroe
Berkeley, California

I first began working with wood when I had a school project to forge some kind of object. I decided I wanted to forge a tree out of wood. If that makes any sense. I sculpted the whole thing out of two-by-fours and one-by-twos. I originally planned to paint it when it was done, but I got caught up in the beauty of the wood grain and couldn't do it. That was the first wood sculpture I made. After that I wanted to make more.

The material relates very directly to the things I'm making. They are all derivative of something in nature—whether it be a fruit or a pile of dirt. I feel like the wood grain brings an unpredictable look and shape to a piece that is related to the growth and life of anything.

I think that a face and expression is such an important part to personality. That's why I want it to be the focus of my work. I really enjoy painting on the eyes and mouth. All that's needed is a few very simple lines to define and bring the thing alive. My characters all have their own personalities, but at the same time they share characteristics, too—kind of like siblings, or even pets and their owners.

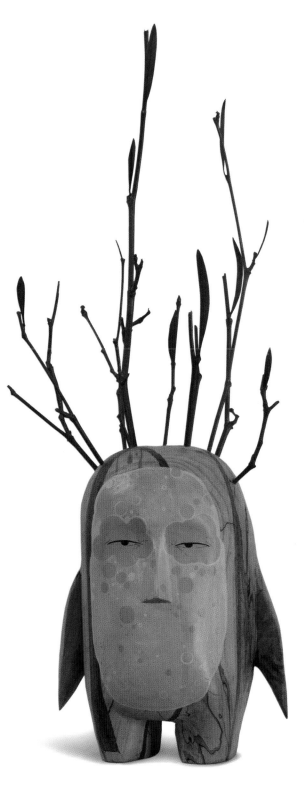

Sour (with branches), 2005
Carved wood, paint
7 x 18 x 6 in

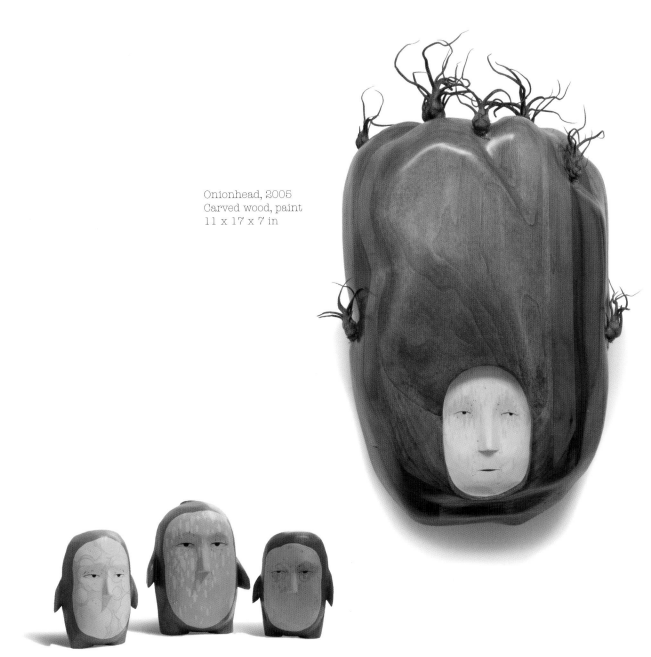

Onionhead, 2005
Carved wood, paint
11 x 17 x 7 in

Sours, 2004
Carved wood, paint
Small 3 x 4 x 2.5 in, Large 5 x 4.5 x 4 in

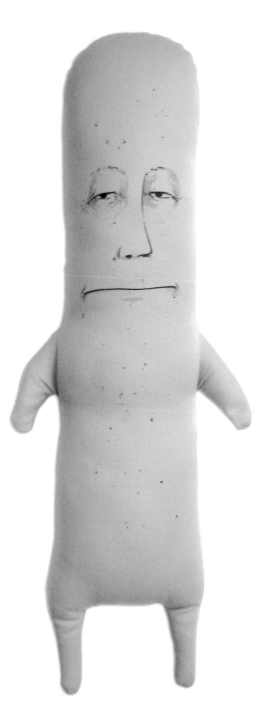

Brumoso, 2004
Silk-screened fabric, stuffing
6 x 16 x 4 in

Project Alabama
Florence, Alabama

Project Alabama is about slow but constant growth, permanence, and pride of community. We use an innovative, cottage industry–based business model that enables contracted artisans to produce garments from their own homes in the spirit of the traditional quilting bee. Each collection is composed of limited-edition custom garments with a modern twist, emphasizing quality of cut, detail, craftsmanship, and style. The techniques are age old yet interpreted in a contemporary way, creating modern design with historical context. We seek to reintroduce the fading art of hand stitching, as this has always been an integral part of American culture. Founded by Natalie "Alabama" Chanin and Enrico Marone-Cinzano, the company was built around the concepts and values illustrated by the quilting tradition, those of craftsmanship and beauty, but also function and utility.

All garments are produced by hand, from start to finish. Chanin and the design team refine all of Project Alabama's designs. The pattern department then crafts patterns for each garment. All garments are cut in-house in Project Alabama's cutting room. The materials are then inspected, packed, sold, and distributed to independent contractors, or "Stitchers," who embroider and construct the garments. Completed pieces are inspected, purchased from the Stitchers, packed, and shipped to stores.

Stitchers are asked to love their threads as they sew because doing so lends warm wishes to the wearer. The Stitchers are artisans—highly skilled and extremely valuable. Because each garment is made by hand, no two are identical. In addition, the Stitcher signs each garment and fabrics are often recycled in the spirit of traditional quilting.

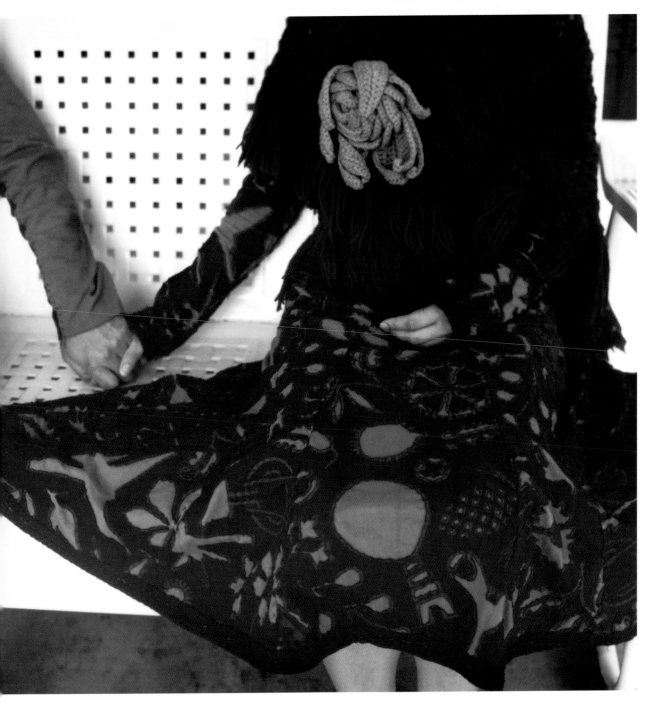

Dress, fall 2004
Sewn fabric
Dimensions variable

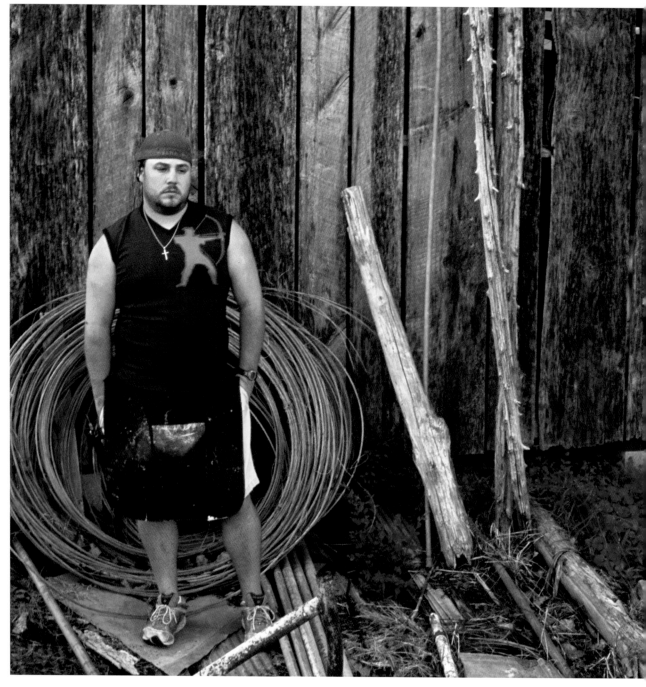

T-shirt, fall 2004
Screen-printed and sewn fabric
Dimensions variable

Spray painting in workshop

Skirt, fall 2005
Sewn fabric
Dimensions variable

T-shirt, fall 2005
Screen-printed and sewn fabric
Dimensions variable

Karen Reimer
Chicago, Illinois

I've pretty much always known how to sew and embroider, but I didn't start using those techniques in my work until college. It started as a whim, but then I thought the results were really interesting, so I carried on with it. I've found that I'm really comfortable with these methods and materials. I know how to do whatever I want with them, and I really like the repetitiveness of it. Embroidery channels my compulsiveness.

In my embroidered copies of book pages, trash pieces, newspapers, or notebook paper, I pin the piece of paper I'm copying directly onto the fabric and sew through it. The original gets destroyed. The trash pieces have no value as originals, but the book pages have value because they hold information. That value is frequently destroyed through embroidery, which is clumsy and makes the copies unreadable. So there's a trade-off of one kind of value for another.

Manual work can change the value and meaning of things that it gets invested in. Embroidery works well for exploring this because it's pointless work, so to speak. Most craft methods were originally used to make something of practical use, but embroidery has always been purely decorative. At most, it's had a use as moral hygiene—to keep genteel women busy, give them something to do, and keep them out of trouble. It is free-floating work, work for its own sake. In this technological age, using hand embroidery is extravagantly inefficient in terms of time and labor. So I end up with an object whose only value is the work that's been put into it.

Chicago Tribune, September 29,
2002, 2002
Embroidery
24.5 x 22 in

Untitled (Notebook
Paper Series), 2004
Embroidery
8 x 10.5 in

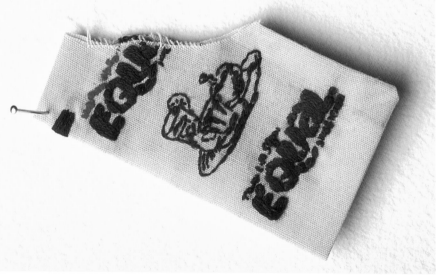

Equal, 1999
Embroidery
1.375 x 2.5 in

Socialist Worker, March 31,
2000, 2000
Embroidery, appliqué
22.125 x 16.5 in

Carolyn Salas
New York, New York

Though I was surrounded by sewers growing up, I was never formally taught, so I taught myself. I bought an old sewing machine from a friend a few years ago and started making clothing and bags. They were pieced together with a sculptural approach, each one an individual piece. I started selling some things at a local designer's flea market in Manhattan, but I realized I was spending more time on making clothing than I was on making artwork, so I decided to transfer my newfound inspiration from clothing to soft sculptures.

I like that sewing allows me to build a structure rather quickly. It's much like working with wood. Though with fabric you get curves and shapes that wouldn't come so easily, even for a skilled woodworker.

My dad has had an influence on the themes in my work. He was a set designer for the film industry when I was growing up. He would tell us, "Oh, I worked on that set." And I would think, "You mean that isn't real?" The illusion of the "real" was dispelled early. The idea of making sets or fake realities has been a consistent theme in my work.

One of my favorite television shows growing up was called *Land of the Lost*. A family goes on a rafting trip and falls over the edge of a waterfall and finds themselves in a fantastical world where prehistoric animals roam and creatures called Sleestaks occupy the land. The sets were really funky and mythical. The attitude was similar to that of the *Twilight Zone*. I really appreciate those shows now because of their handmade qualities, as opposed to the computer-generated sets we have today.

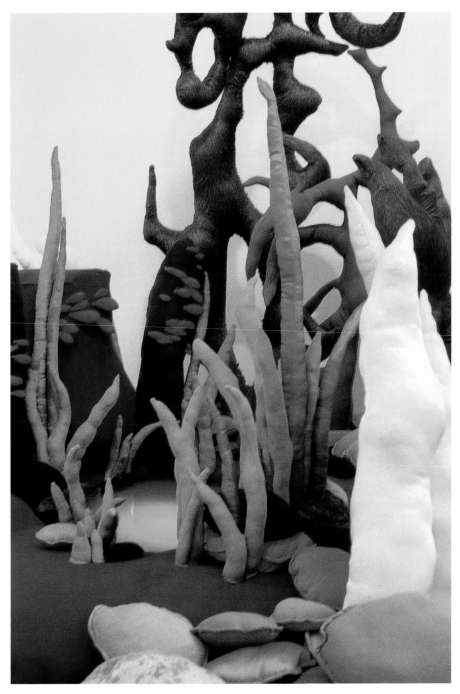

Untitled, 2005
Fabric, poly-fill, chicken wire,
wood, Plexiglas, artificial light
6 x 8 x 6 ft

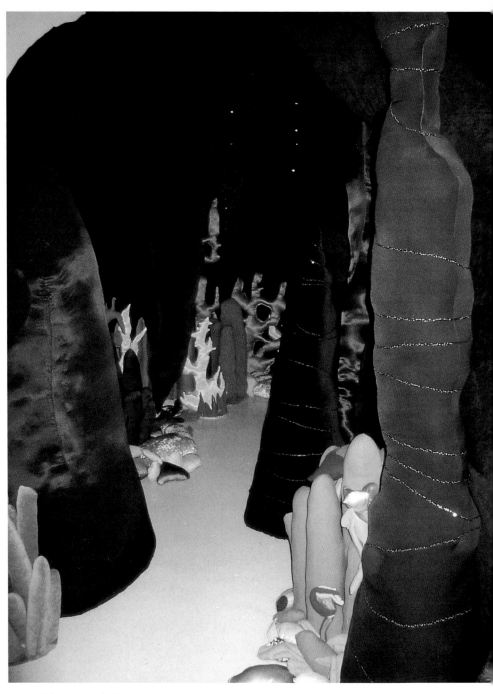

Above and facing page
Sometimes I Feel Like an Underwater Sea
Creature That Has No Eyeballs, 2004–2005
Fabric, polyfill
20 x 15 x 12 ft

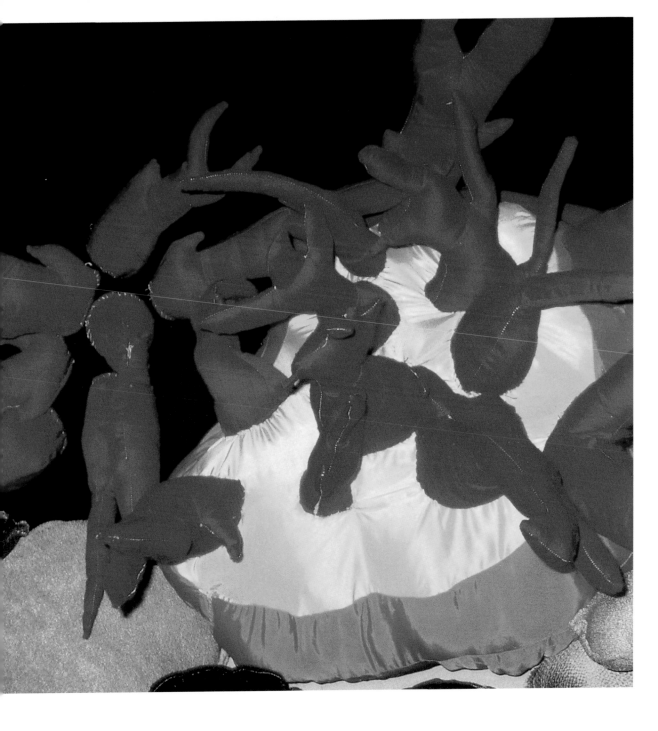

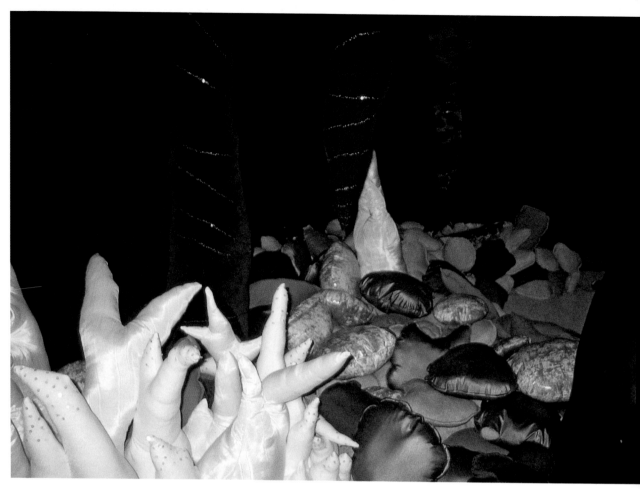

Sometimes I Feel Like an Underwater Sea
Creature That Has No Eyeballs

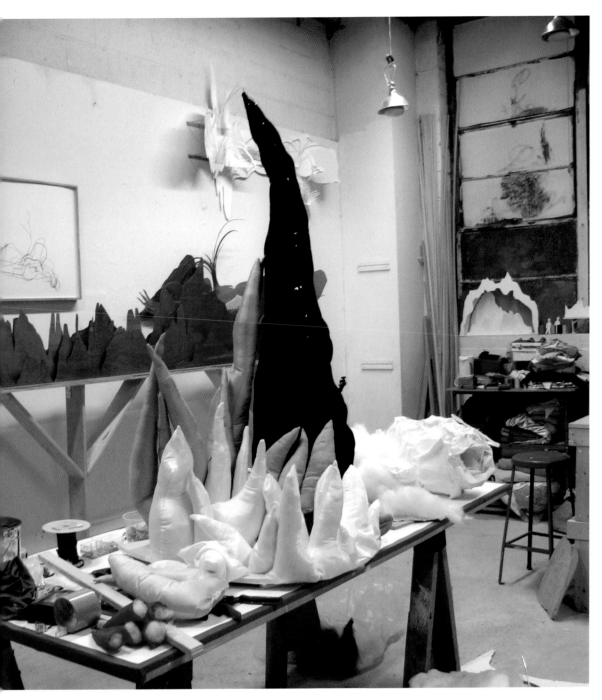

Studio overview

Tucker Schwarz
San Francisco, California

I create drawings that are sewn onto fabric. These are based on photographs I have taken. I draw the image onto the fabric with a water-soluble marker, sew the image using a sewing machine, and then wash away the original ink. I am attracted to the tangible nature of fabric and choose muslin or canvas because of its neutral color. It is the fabric that is closest to paper. I prefer the muslin these days because it is thin and responds well to the thread by puckering and creating texture.

The dangling threads on the works are metaphors for fragility and the tentative and changing nature of emotions and relationships. I hope I can say all the things I want in the most succinct and moving way with my work. I am interested in subtle, quiet images that trigger memories and emotions. The places I depict strike the biggest chord for me. These are the places where the most important things or moments happen—everyday places. The everyday is the most heartbreaking sometimes.

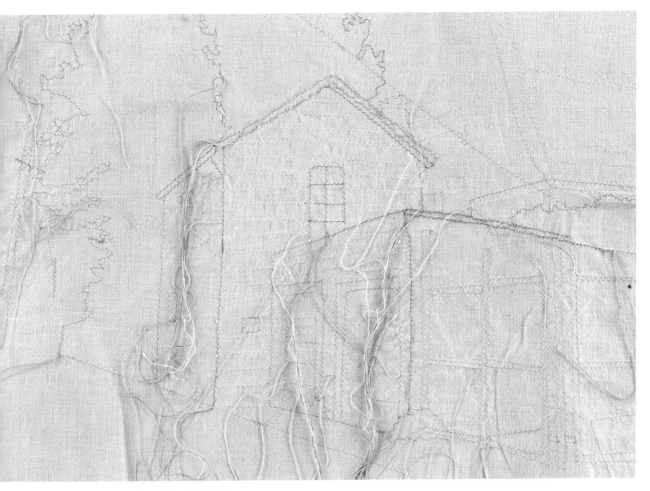

I Was Lying When I Said... (detail), 2005
Thread on muslin
43.5 x 24.5 in

I Guess I'm Just... (detail), 2005
Thread on muslin
39.5 x 49.5 in

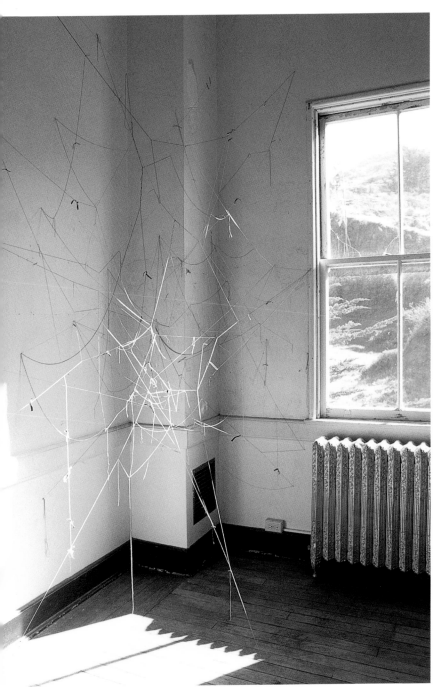

Thinking of You, 2005
Thread and fabric installation
Dimensions variable

Slow and Steady Wins the Race
New York, New York

Slow and Steady Wins the Race asks the following questions: Why do experimental ideas only exist in the high-priced, avant-garde realm? Why do the Gap and H&M only provide trickle-down basics? Slow and Steady Wins the Race transposes these two different arenas into each other. It is a new clothing label cataloging ideas that are focused on a specific and fundamental characteristic of clothing design. With each issue, Slow and Steady Wins the Race intends to enact a more democratic dissemination, promotion, and appreciation of clothing. The mission of the label is to push and produce interesting and significant pieces from the simplest fabrics and materials. The catalogs are meant to be shared, to be passed from hand to hand. The same intention applies to the clothing.

The work process for Slow and Steady Wins the Race is very controlled. Each issue is devoted to a particular fundamental design platform. Arriving at that theme involves a round of brainstorming, list making, and editing until the strongest idea is reached.

The themes range from seams and the exploration of how clothing pieces are joined together to subverting existing characteristics of traditional garments and accessories. All clothing is made by hand because it is both cost effective and a resistance to mass-market, high volume, sweatshop promotion.

Slow and Steady Wins the Race is a quiet reaction to the considerable amount of waste in the ever-changing fashion industry. The aim of Slow and Steady Wins the Race is to yield a limited number of fresh pieces in a regulated pace throughout the calendar year. This accelerated pace is a commentary on modern fashion's temporal nature. The costs and quantity of production are purposefully kept low to help promote the idea of a democratic and grassroots distribution.

Through this visual and social metaphor, Slow and Steady Wins the Race hopes to have its ideas and products reach a wide audience and foster the appreciation and creative progression of clothing design.

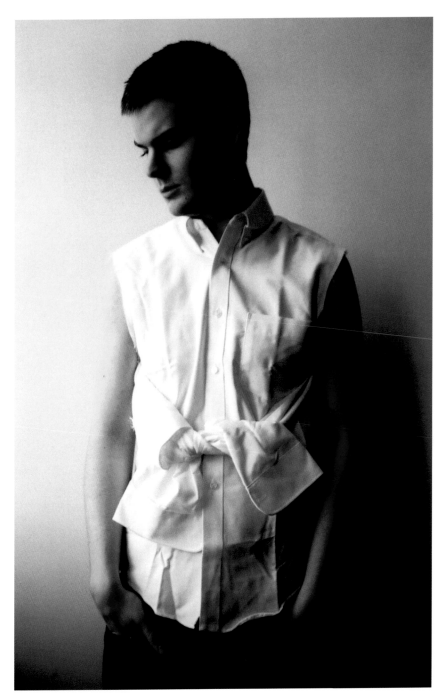

Folded Arms, 2004
Sewn fabric
Dimensions variable

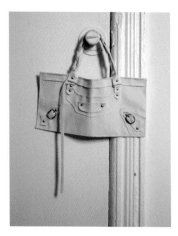 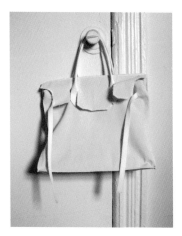 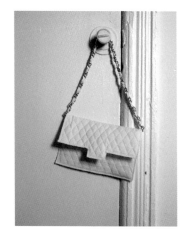

From left
Balenciaga, 2003
Sewn fabric
15 x 7.5 x 2 in

Birkin, 2003
Sewn fabric
14 x 12 x 8 in

Chanel, 2003
Sewn fabric
11.5 x 7.5 in

Facing page
Hybrid, 2005
Sewn fabric
15 x 17 in

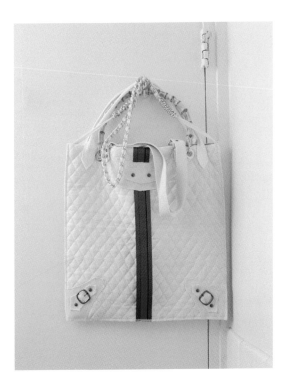

Kiki Smith

New York, New York

I had an Aunt Graziella who came from a sort of wealthy, uptown, Puerto Rican family, and she was taught how to make leis and sew and to embroider—kind of in an old-fashioned way, like nineteenth-century traditional "women's work," traditional craft. My parents didn't do any of those things, but my aunt taught me to knit and to sew. And I enjoyed doing that. I just liked it.

In a way, I was embracing my gender-cultural history. I didn't want to be confined by it, but I also didn't feel the necessity to negate it. I thought, "This is my cultural history"—not my specific cultural inheritance, because I grew up with people from the abstract expressionist generation, but I really enjoyed making things.

I'm not particularly adept at making things. But slowly I've become a little bit better. And in a certain way I like the challenge of not being good at making something. I like that it's a lot of work, that it's a struggle. There's something very satisfying about almost getting it right.

When I was younger I didn't draw at all because I was so bad at it. Lots of artists have talent, and I've had friends who have a lot of aptitude. My best friend when I was young could do anything. But it just didn't mean anything to her. I think because I'm not good at doing things, it means something to me.

I like all different forms. They all are interesting and they each give you a different kind of opportunity. I wish that I was good at design, but for most things like that I have absolutely no idea and so I suffer because I know that they are really great forms. I mean I know that if I had an idea it would be a really great place to have an idea. You might not have an idea and sometimes there's nothing you can do about it. You're just stuck with your limitations and then you suffer a little bit. But, in general, I just want to do as many different things as I can and to be able to impact the world in daily life.

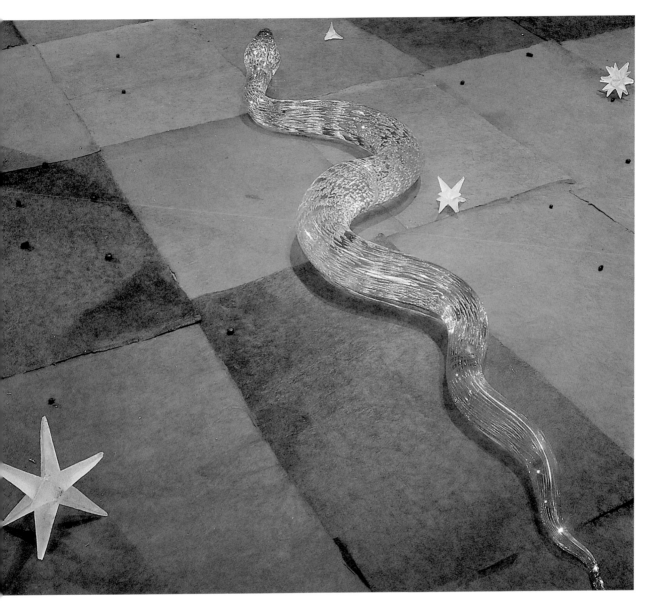

Constellation (detail), 1996
26 glass animal units, 630 bronze
scat units, 67 glass star units
Dimensions variable

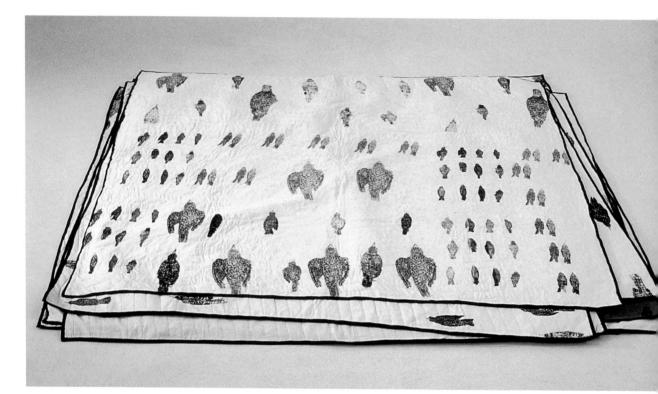

White Blanket, 1998
Silk screen on quilted blankets
Ten blankets, each 64 x 67 in

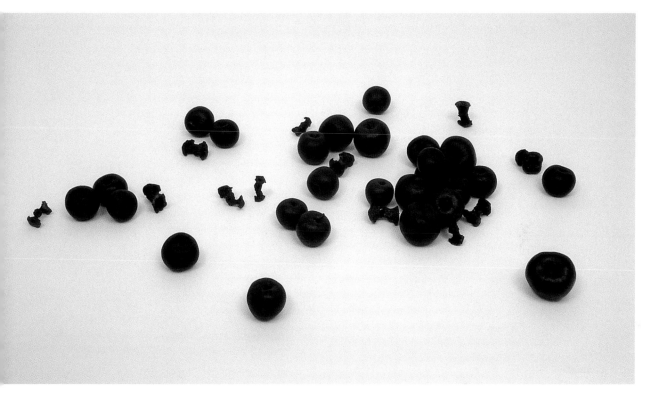

Black Apples, 1999
Thirty-eight bronze units
Dimensions variable

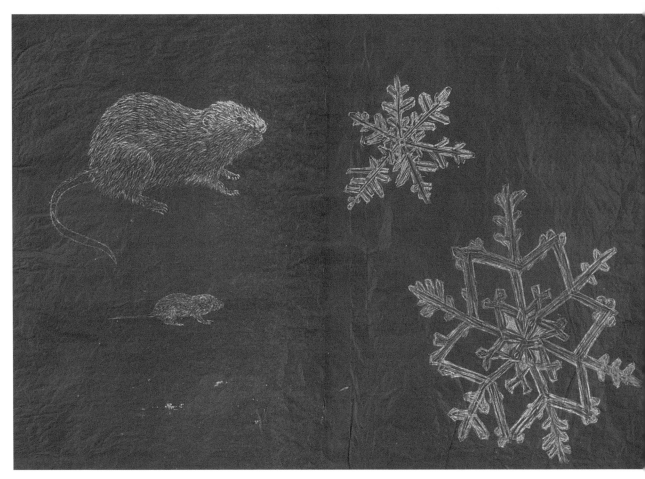

Little Rodents with Snowflakes, 1996
Ink on paper
34.75 x 23.5 in

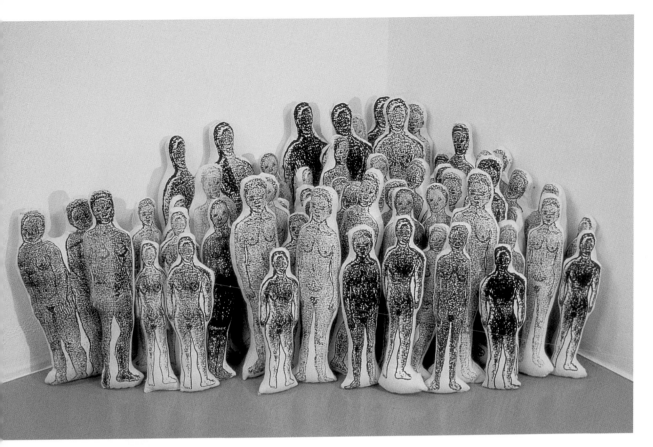

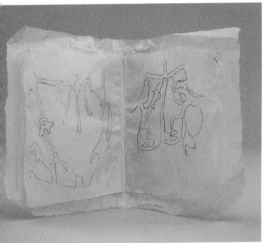

Above
Lucy's Daughters, 1990
Silk screen on cloth
Sixty units, dimensions variable

Left
Nasal Cavity, 1995
Handmade book, ink on paper
3.75 x 5 x .75 in

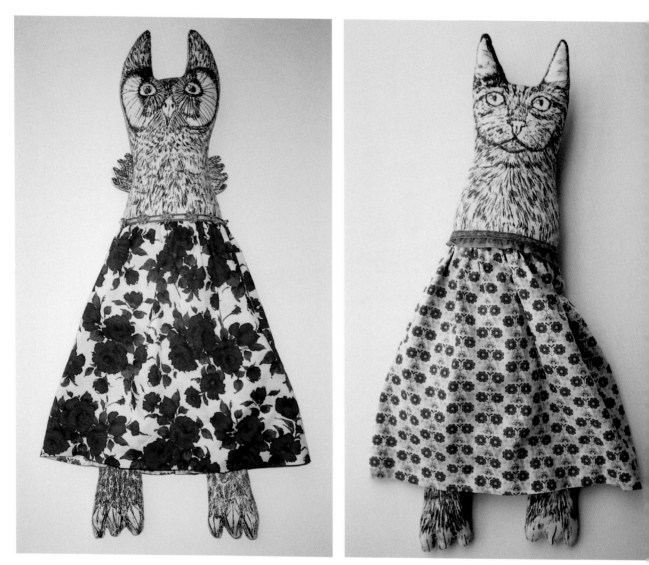

Owl and Pussycat, 2002
Pigment on cotton sateen
with Liberty print fabrics
11 x 23 x 3 in

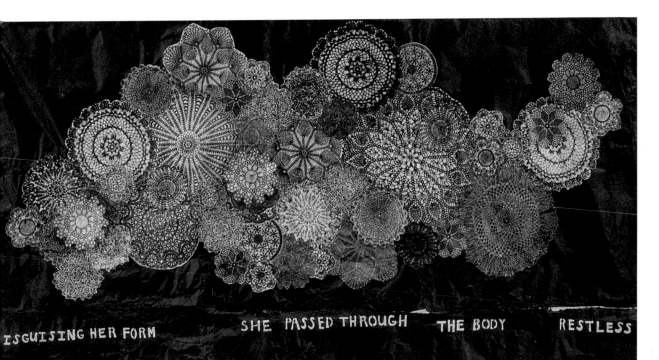

ISGUISING HER FORM SHE PASSED THROUGH THE BODY RESTLESS

Restless Drawing, 1994
Collaged letterpress and lithograph
on Nepal paper
89.5 x 47 in

Little Banshee Pearls Book, 1992
Handmade book, printing ink on
Nepal paper
7.25 x 8 x .25 in

Aaron Spangler

Brooklyn, New York, and Two Inlets, Minnesota

When I was a child, my brother and I built an enormous cardboard space station for action figures that filled an entire half of the family room. That was my first sculpture.

In college I made representational sculptures out of found wood. They reflected various interests of mine—guns, boats, tanks, and other war-related things. I was interested in buildings with social value, like courthouses, churches, and prisons. One sculpture, a churchlike building that was also a railroad depot, sat on a platform in front of some railroad tracks. To reference the bas-reliefs found in both government buildings and churches, I carved depictions of hell inside the building with a screwdriver.

I don't have much of a plan when I start a work, but I sketch onto the wood itself. My studio is filled with photos for atmosphere and remembrance, but I don't usually take directly from them. Usually I carve a single object and immediately paint it with black gesso. This way I begin to see a direction that the picture might take. I start with a single image and a possible theme. As I add to these images, a visual narrative begins to take shape.

I like the process of carving and the fact that I can create illusionary space in bas-relief, as opposed to the actual space created in three-dimensional sculpture. I do not focus on technical ability in my work. Instead, the daily activity of carving is a way of expressing my imagination. I learn specific carving techniques as I go, and the skill is always in the service of my imagination.

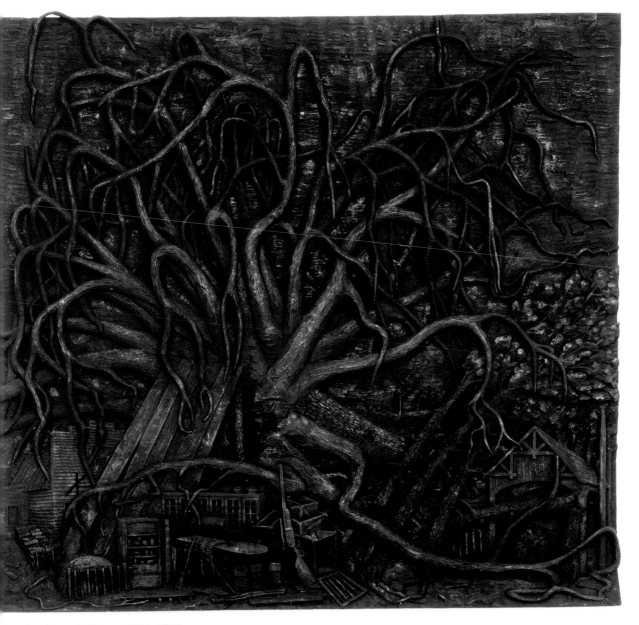

The Sniper's Home, 2004–2005
Wood, black gesso
36 x 32 x 4 in

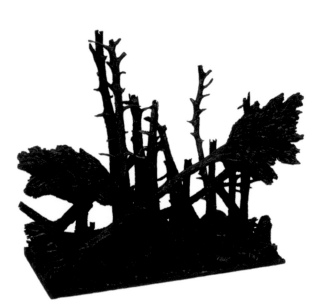

Above
The Stockade, 2005
Wood, black gesso
22 x 11 x 21 in

Right
Imperial Trees, 2005
Wood, black gesso
72 x 60 x 5 in

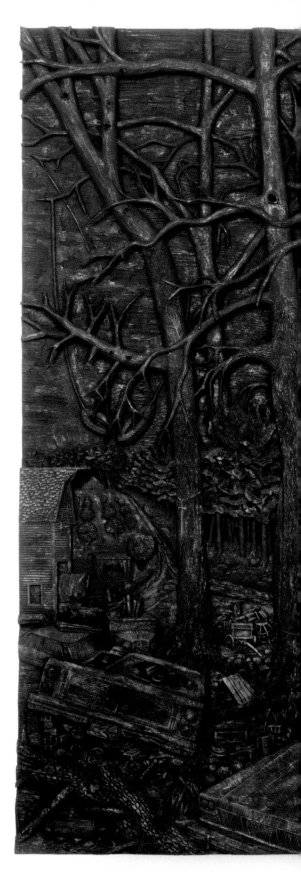

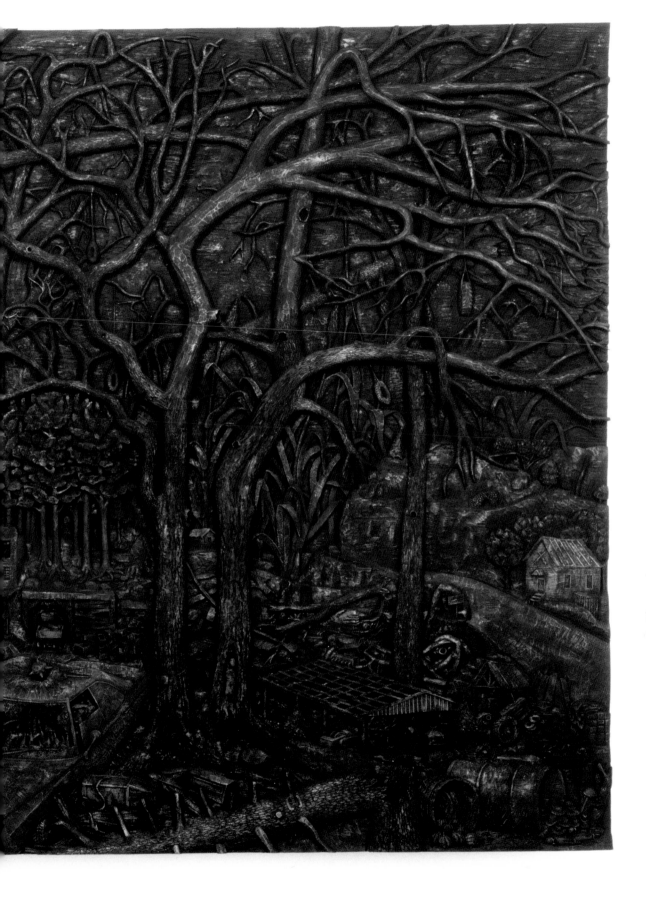

Work in progress in studio

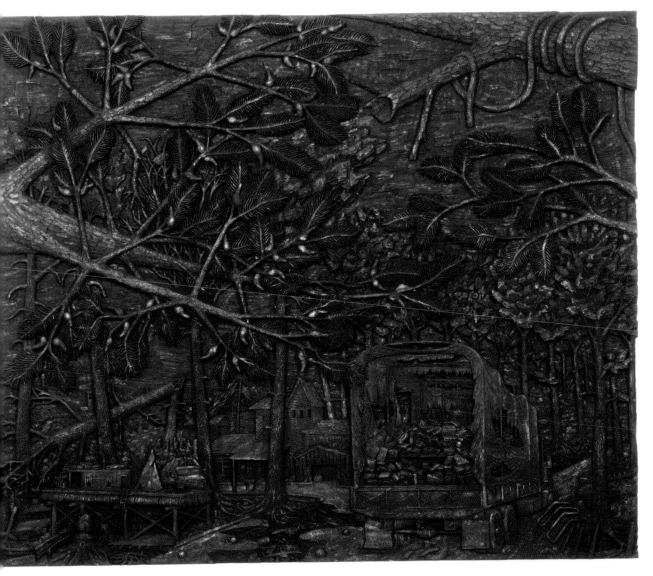

Useless Knowledge, 2004–2005
Wood, black gesso
72 x 60 x 5 in

Anna Von Mertens
Berkeley, California

Because I started as a traditional quilt maker, producing quilts from clothes from the Salvation Army, I was originally simply attracted to the materials—the play of color in pattern and the tactility of the fabric. After making the shift from using quilts as my medium to using the bed itself as my medium, the content that was latent in the materials became more meaningful. Instead of embracing the intimacy and appeal of the materials just for their own sake, I used the intimacy evoked by the materials to match the content in my work.

I find it ironic that I am caught in a place where I am pushing the craft of quilting forward by making the work conceptual, but I am also an ultra-traditionalist, as all of my works are made to fit a single or queen-size bed and shown on the form of a bed. All of my works are hand-stitched, which is the most traditional element of all. For me rich associations come from the site of the bed and the evidence of the hand, so those are the elements I keep.

I try not to focus too much on how much time it takes me to make a piece, otherwise I'd never start a new one. It can take up to three months to make a piece. I start with an abstract idea that I then try to link with a pattern. After completing my research I draw my stitch pattern on the computer.

The hand-stitched line is an important element in my work. The evidence of the hand evokes time and contemplation, almost as a commitment to the ideas contained within the work. When I stitch diagrams of military explosions, those explosions are seen from a different vantage point because they are stitched in a slow, deliberate way. The hand-stitched line acts as a tracing—as if my fingers were slowly tracing the pathways that I am stitching as a way to map them and as a way to understand them.

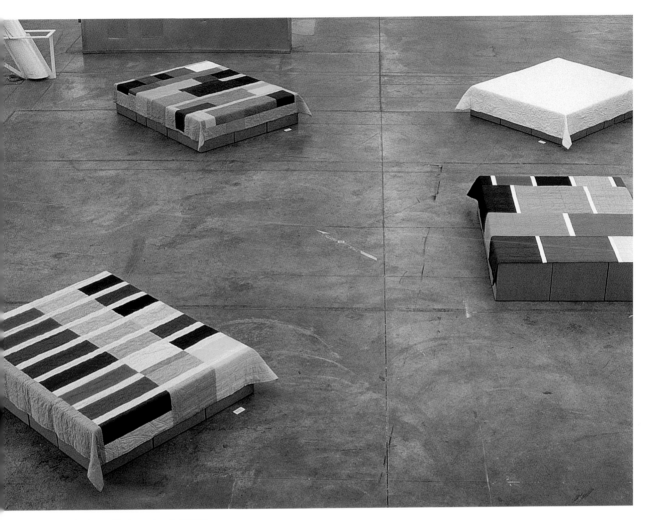

True North (installation view), 2000
Hand-stitched cotton
Each piece 15 x 60 x 80 in

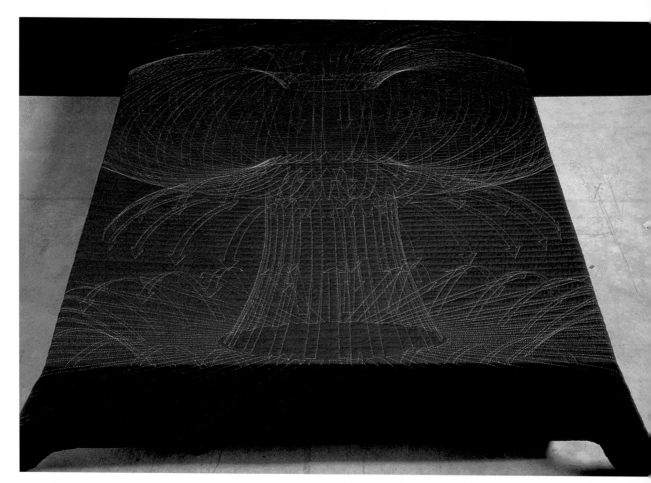

This and facing page
Black and White (detail), 2004
Hand-stitched cotton
Each piece 17 x 180 x 80 in

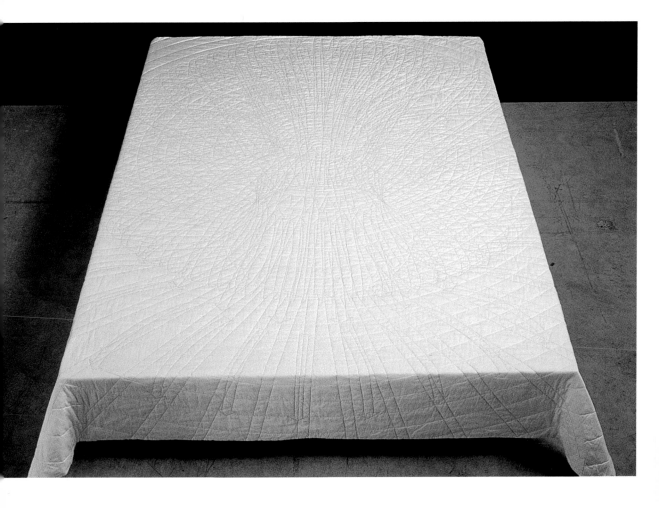

North (detail), 2003
Hand-stitched, hand-dyed cotton
15 x 60 x 80 in

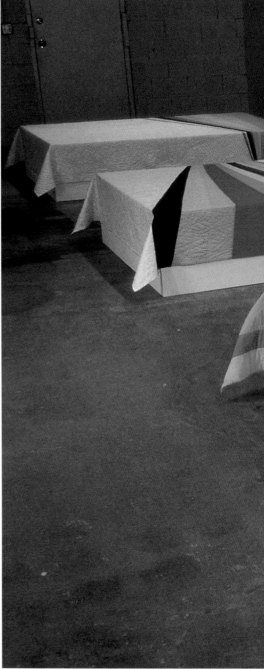

Black and White, Shades of Gray
(installation view), 2004
Hand-stitched, hand-dyed cotton
Each piece 60 x 80 x 17 in

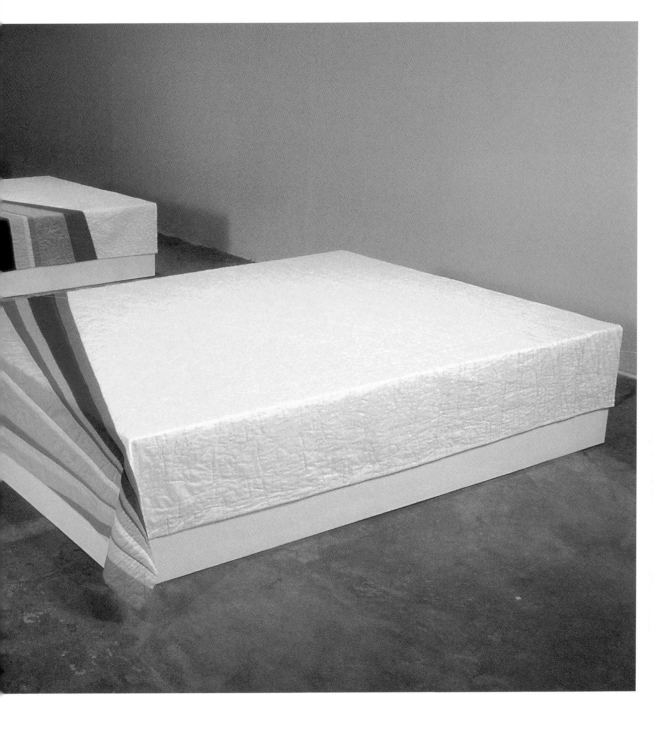

Shane Waltener
London, England

Coming from Belgium plays a big part in my work. There is a long history of lace and textiles being produced there, in Flanders in particular. I grew up surrounded by bourgeois fineries. I then left for London and found myself trying to recreate that environment. I'm much influenced by my mother, who worked as an interior designer and a homemaker. She never taught me how to knit—boys didn't do this—but now assists me on some of my projects.

My work is about celebrating and rediscovering craft and addressing the balance between art and craft. Knitting with elastic thread allows me to create monumental pieces that challenge the architecture and authority of a given space. The knitting performances I create are about the social aspect of the craft. They are less about the piece being produced than about the exchange between participants. Each stitch contains a thought and these are entered onto a network (the knitted loop) and passed around by all the knitters in the circle. The loop is then exhibited as a document tracing the history of the event.

Contemporary art reinvents itself by looking outside its own area for inspiration—be it politics, science, or technology. Right now, craft seems to play a bigger part in how and why art is produced. It probably has something to do with the recent interest in "slow work" and regaining control over our lives by slowing things down. Looking at something that has demanded a long production time is very rewarding. There has been an unnatural division between art and craft, at least in Europe and the United States. Craft has been marginalized on account of our infatuation with ideas of modernity and progress. Elsewhere is has remained associated with rituals, magic, and spirituality. It has remained at the center of cultural production. This is the reason I am interested in presenting the knitted work in a public context.

Sweet Nothings: An Intimate
History of Cake Decorating, 2005
120 decorated cakes
Dimensions variable

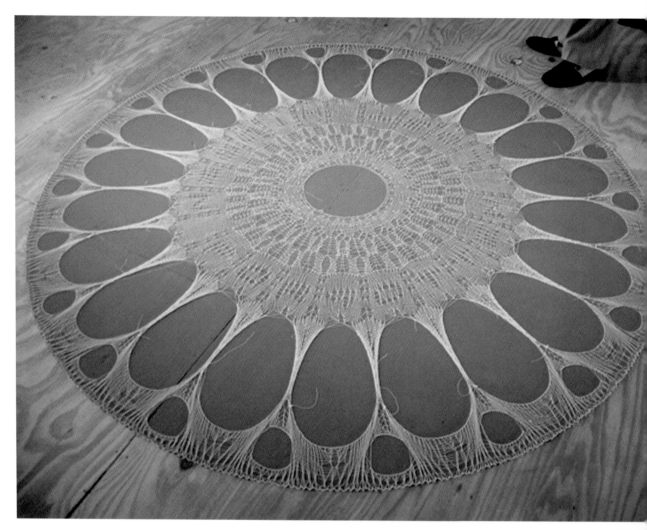

Above
Lost, Hidden, Forgotten, 2005
Shirring elastic, nails, paint
90 x 90 in

Right
Over Here (table center detail), 2005
Shirring elastic, table, nails
20 x 20 in

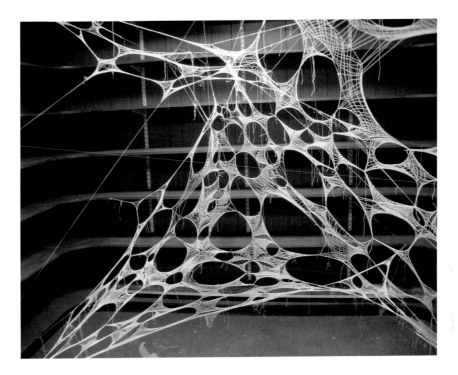

Showroom Doily (detail), 2004
Shirring elastic
24 x 24 x 12 in

Rob Wynne
New York, New York

When I have an idea I try to figure out what material will be the most expressive for that idea. I just think of something and then consider what will be most effective, most interesting. I love decorative arts and I love craft materials, so I often end up working with these processes.

I began working on my thread drawings through a bit of an accident. I used to be an abstract painter and I was searching for a way out of that world. It was meaningless for me. I felt really attracted to narrative and storytelling, and I began thinking about reading problems and my dyslexia. I began doing these machine-made embroideries with text and eventually decided that I would try to sew some by hand. I didn't have any paper around—just some tracing paper—so I started with the tracing paper. As I was working I began to see the how the tangle of thread behind the paper showed through to the front where my words were forming, and I realized that I'd discovered a way to express the relationship between abstract thought and concrete thought. By looking through the drawing you can see the confusion that informs the clarity on the surface. It's like process art. It's conceptual, but also very much about the activity of doing it.

After a while I began thinking about how else the question of language could be addressed, and I've always been interested in glass, so I developed a process to draw with glass. When I'm making the glass work, it's quite hysterical and high-pitched. You have all of these torches, the furnace, things breaking, smoke. You can't hear. You have to scream to the other people. It's very dramatic, very operatic. Which I love. But you have very minimal control over it. The glass does what it wants to do because it's not being poured into a mold. I draw it out first, and we try to approximate the drawing in the production, but it's never precise. It's a bit like cooking. You can make certain adjustments while you're working. Add some salt. But you can't go back once it's done.

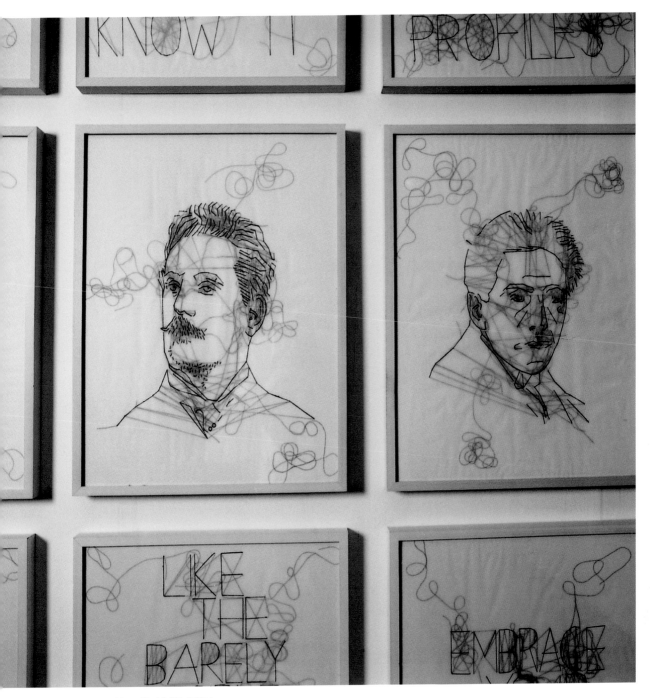

Thread Drawings (detail), 1999–2004
Thread and vellum
Each 18 x 24 in

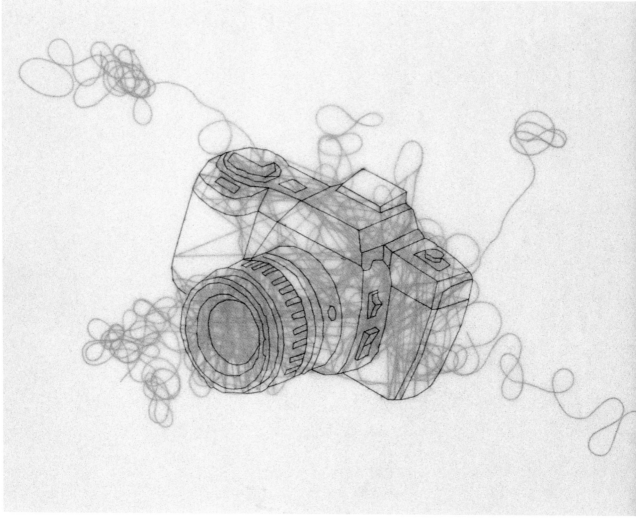

Camera, 2002
Thread and vellum
24 x 18 in

Flashlight, 2002
Thread and vellum
24 x 18 in

You Could Almost Smell the Roses, 1999
Thread and vellum
18 x 24 in

Selected Words, 2002
Handmade book, letterpress
13.75 x 18.5 in

Contact Information

Satoru Aoyama
Represented by Mizuma
Art Gallery, Tokyo
mizuma-art.co.jp

BB&PPINC
bbandppinc.com

Kelly Breslin
info@kmbreslin.com

Margarita Cabrera
Represented by Sara
Meltzer Gallery, New York
sarameltzergallery.com

Rachel Cattle
rachelcattle.co.uk

Dave Cole
Represented by Judi
Rotenberg Gallery, Boston
judirotenberg.com

Robert Conger
Represented by Mixed
Greens, New York
mixedgreens.com

Daphne and Vera Correll
Represented by Opening
Ceremony, New York
openingceremony.us

Frederique Daubal
daubal.com

Rowena Dring
rowenadring.com
Represented by Elizabeth
Dee Gallery, New York

dynamo-ville
dynamo-ville.com

electricwig
electricwig.com

Evil Twin Publications
eviltwinpublications.com

Tess Giberson
tessgiberson.com
Represented by Kaleidoscope
Consulting, New York

Kirsten Hassenfeld
Represented by Bellwether
Gallery, New York
bellwethergallery.com

Kent Henricksen
Represented by John
Connelly Presents, New York
johnconnellypresents.com

Barb Hunt
bhunt@swgc.mun.ca

Aya Kakeda
ayakakeda.com

Andrew Kuo
andrewkuo.com

Robyn Love
robynlove.com
thehousemuseum.ca

Victoria May
Represented by Don Soker
Contemporary Art, San Francisco
donsokergallery.com

Brendan Monroe
brendanmonroe.com

Project Alabama
projectalabama.com

Karen Reimer
Represented by Monique
Meloche Gallery, Chicago
moniquemeloche.com

Carolyn Salas
Represented by Priska C.
Juschka Fine Art, New York
priskajuschkafineart.com

Tucker Schwarz
tuckerschwarz.com
Represented by Gregory
Lind Gallery, San Francisco

Slow and Steady Wins the Race
slowandsteadywinstherace.com

Kiki Smith
Represented by Pace
Wildenstein, New York
pacewildenstein.com

Aaron Spangler
Represented by Zach
Feuer Gallery, New York
zachfeuer.com

Anna Von Mertens
annavonmertens.com
Represented by Gallery
Paule Anglim, San Francisco,
and Lizabeth Oliveria Gallery,
Los Angeles

Shane Waltener
shanewaltener.co.uk

Rob Wynne
Represented by JGM Galerie,
Paris, Raphael Castoriano Fine
Art, New York, and Rebecca
Ibel Gallery, Columbus, OH

Credits

Satoru Aoyama
All images courtesy of the artist
and Mizuma Art Gallery, Tokyo

BB&PPINC
All images courtesy of the artist
except *The Party Book*, courtesy
of Jon Wasserman

Kelly Breslin
All images courtesy of the artist

Margarita Cabrera
Vocho (yellow) courtesy of Sara
Meltzer Gallery, New York, and
private collection; *Pink Blender*
courtesy of Sara Meltzer Gallery,
New York, and private collection;
Cleaning Supplies courtesy of the
artist and Sara Meltzer Gallery,
New York; *Coffee Maker M.I.M.* cour-
tesy of Sara Meltzer Gallery, New
York, and private collection

Rachel Cattle
All images courtesy of the artist

Dave Cole
Artist portrait courtesy of Matt
Cottam; all other images courtesy
of Judi Rotenberg Gallery

Robert Conger
All images courtesy of the artist
and Mixed Greens, New York

Daphne and Vera Correll
All images courtesy of
Jon Wasserman

Frederique Daubal
All images courtesy of the artist

Rowena Dring
Artist portrait courtesy of
Phil Sayers; all other images
courtesy of Elizabeth Dee
Gallery, New York

dynamo-ville
All images courtesy of
Jon Wasserman

electricwig
Crocheted Lampshade image
courtesy of Tas Kyprianou;
Perfectly Folded Shirt image
courtesy of Trico; Muji Mook
image courtesy of *Casa Brutus*
magazine

Evil Twin Publications
All images courtesy of
Jon Wasserman

Tess Giberson
Fall 2003 images courtesy of
Jonah Freeman; spring and fall
2004 images courtesy of John
Minh Nguyen; artist portrait
courtesy of Lizzie Owens

Kirsten Hassenfeld
All images courtesy of the artist
and Bellwether, New York

Kent Henricksen
All images courtesy of the artist
and John Connelly Presents

Barb Hunt
Antipersonnel images courtesy
of the artist and the Agnes
Etherington Art Centre, Kings-
ton, Canada Purchase, York Wil-
son Endowment Award, Canada
Council for the Arts, 2005;
Incarnate image courtesy of Jill
Kitchener

Aya Kakeda
All images courtesy of the artist

Andrew Kuo
All images courtesy of the artist;
artist portrait courtesy of
Joshua Wildman

Robyn Love
Standing Still images courtesy
of Jamie Permuth

Victoria May
All images courtesy of the artist;
artist portrait courtesy
of T. S. Anand

Brendan Monroe
All images courtesy of the artist

Project Alabama
Garment and workspace images
courtesy of Robert Rausch

Karen Reimer
Images courtesy of the artist,
Monique Meloche Gallery, Chicago,
and Tom Van Eynde; artist por-
trait courtesy of Laura Letinksy

Carolyn Salas
All images courtesy of the artist

Tucker Schwarz
All images courtesy of the artist

Slow and Steady Wins the Race
All images courtesy of the artist

Kiki Smith
All images courtesy of Pace
Wildenstein, New York; artist
portrait courtesy of Joe Magliaro

Aaron Spangler
All images courtesy of the artist
and Zach Feuer Gallery

Anna Von Mertens
Images of *Black and White* and
North courtesy of Don Tuttle
Photography; image of *Black
and White, Shades of Gray*
courtesy of Joshua White;
image of *True North* courtesy
of Jean-Michel Addor

Shane Waltener
All images courtesy of the artist

Rob Wynne
All images courtesy of the artist
except *Thread Drawings* group
image and *Selected Words*,
courtesy of Jon Wasserman

This publication is set in ITC
American Typewriter Light.
The American Typewriter font
family was designed by Joel
Kaden and Tony Stan in 1974
for the International Typeface
Corporation. Its letterforms
recall those tapped out on pre-
digital machines, however, it is
not monospaced like a tradition-
al typewriter face. Letterspacing
and pairing have been adjusted
to improve the legibility of this
typeface.